IMAGES
of America

BIRMINGHAM

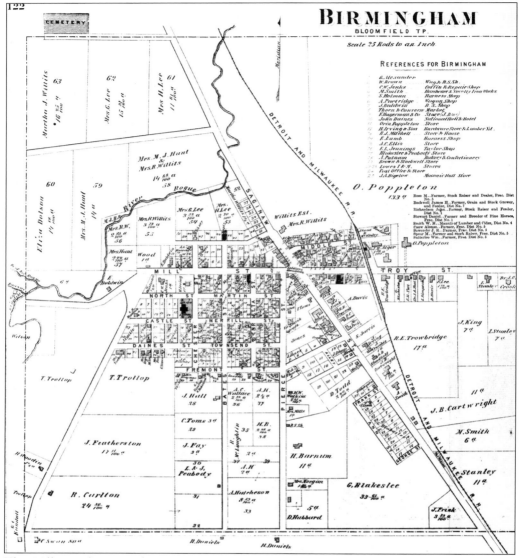

BIRMINGHAM
BLOOMFIELD TP.

Scale 25 Rods to an Inch

REFERENCES FOR BIRMINGHAM

1	G.Alexander	Wag.& B.S.Sh.
2	W.Brown	Coffin & Repair Shop
3	C.W.Jenks	Hardware & Novelty Iron Works
4	M.Smith	Harness Shop
5	S.Holman	Wagon Shop
6	A.Partridge	B.S. Shop
7	J.Baldwin	Market
8	Thorn & Converse	Store & J.Bar.
9	E.Hagerman & Co	National Hotel & Hotel
10	John Barnes	Store
11	Orin Poppleton	Hardware Store & Lumber Yd.
12	R.Irving & Son	Store & House
13	B.J.Mitchell	Harness Shop
14	E.Lumb	Store
15	J.C.Ellis	Taylor Shop
16	E.L.Jennings	Bakery & Confectionery
17	Blakeslee & Peabody	Store
18	J.Putnam	Stores
19	Brown & Stockwell	Masonic Hall Store
20	Lowes I.& M.	
21	Post Office & Store	
22	J.A.Bigelow	

The Village of Birmingham was incorporated on January 8, 1864. The population was approximately 550, and the village was little more than a cluster of frame houses and modest businesses huddled near the corner of Mill Street (Maple) and Saginaw Street (Old Woodward Avenue). Village Line Road (Lincoln) marked the 640-acre community's southern boundary. By the time this map was created in 1872, the population had increased to about 650.

On the cover: With the Birmingham Theatre as its beacon, the town of Birmingham has always been a destination where families, fun, and commerce converge. In the 1940s, when this photograph was taken, moviegoers often stopped after the picture for a milk shake at Cunningham Drugs' soda fountain, located in the Briggs Building, or a hamburger at the White Tower, just to the left of the Birmingham Theatre Building. (Courtesy of the Birmingham Historical Museum and Park.)

IMAGES
of America

BIRMINGHAM

Craig Jolly
with the Birmingham Historical Museum

ARCADIA
PUBLISHING

Published by Arcadia Publishing
Charleston SC, Chicago IL, Portsmouth NH, San Francisco CA

Printed in the United States of America

Library of Congress Catalog Card Number: 2007924634

For all general information contact Arcadia Publishing at:
Telephone 843-853-2070
Fax 843-853-0044
E-mail sales@arcadiapublishing.com
For customer service and orders:
Toll-Free 1-888-313-2665

Visit us on the Internet at www.arcadiapublishing.com

CONTENTS

ACKNOWLEDGMENTS

Even a modest book such as this requires contributions from many people to make it a success. None is more deserving of my thanks than Hartland Smith. Born in 1922 and a fifth-generation Birmingham resident, Hartland is both a raconteur and historian. He probably knows more about Birmingham's past than anyone else alive. Many of the stories told on these pages come from Hartland's family folklore.

I would also like to thank Bill McElhone, Leslie Mio, and Jenny Ezzo of the Birmingham Historical Museum and Park. They played a vital role in all phases of the development of this book, including research, editorial, design, production, and distribution. Their talent and contributions are greatly appreciated—and it was fun!

Special thanks also to current Birmingham mayor Tom McDaniel, who was very helpful in getting this project started. This book would not have been published if he had not given it a push.

Additional thanks to Jack and Betsy Kausch, Kermit Ambrose, Robin Adair, the family of Roddy Henderson, Dave Breck, Bob Fox, Gigi Nichols and the Community House, John Heiney and the Principal Shopping District, Max Horton, Ann Larson, Dianne Osmialowski and Holy Name Church, Russ Gibb, Susan and Nancy Peabody, Charlie Auringer and *Creem* magazine, Nancy Smith, Don Carney, Bob Kenning, Tom Markus and the City of Birmingham, Carla Cleary, Harvey Kurth, Marc Secontine and the Varsity Shop, Loraine Campbell, Jack Steelman, Anna Wilson and Arcadia Publishing, Joan Tanis, Pat Andrews, Chris Luce Studios, Lauren Brown, Baldwin Public Library, Sen. Carl Levin, and Darla Warren.

Most of the approximately 230 images found in this book are from the archives of the Birmingham Historical Museum and Park. The total collection includes over 1,000 items from all periods of Birmingham's history. Those interested in obtaining copies of the photographs in this book, or other images relating to the history of Birmingham, please visit the museum or call 1-248-644-2817.

INTRODUCTION

Birmingham today is a town of Little League games, concerts in the park, tidy brick bungalows, fireworks over Lincoln Hills, and trips to the Dairy Mat. It is also a town of tony boutiques, elegantly landscaped estate homes, snazzy European sports cars, and people-watching that is as good as it gets for a community that does not have palm trees, movie stars, or a 3,000-foot vertical drop.

Here, vaguely in the shadow—perhaps even the pall—of the Midwest's struggling industrial giant, is one of the nation's most distinctive and appealing small towns. A glitzy, moneyed crowd is here, to be sure. But so are ordinary folks who work their gardens and attend ice-cream socials just like in any other town. These two seemingly disparate groups coexist side by side, mostly in harmony. And perhaps this is the key to Birmingham's success: no matter how Range Rover–gridlocked and poseur-packed Birmingham gets on a busy Saturday night, its folksy, blueberry pie midwestern roots are always showing.

The story of Birmingham begins just like that of many towns scattered across the Midwest: settlers in search of cheap land and a new beginning. John West Hunter, Elijah Willits, and John Hamilton were the first to arrive. Hunter came from Auburn, New York, with his wife and children and paid about $2 an acre for 160 acres of land along an old Potawatomi trail that meandered from Detroit to Pontiac. Hunter built a log cabin in the winter of 1818–1819 with his brother Daniel near today's intersection of Old Woodward and Maple Roads. Hunter's wife Margaret, daughters Harriet and Huldah, and father Elisha soon followed him to what is now Birmingham. In 1822, Hunter replaced the family's cabin with a plank-sided house that is now located at the Birmingham Historical Museum and Park, near the current intersection of Maple Road and Southfield Road.

Because Birmingham was exactly a day's journey from Detroit, all three of the original settlers opened taverns in their homes to serve travelers on wagon or horseback on what became known as the Saginaw Trail. That they were not farmers is significant; their taverns formed a settlement. Within a few years after Hunter's arrival, Birmingham became a modest commercial hub for area farmers who brought their crops to Birmingham's gristmill and secured the necessities of life in Birmingham's markets.

As a pioneer outpost, Birmingham was called Hamilton's by most people. After a few years, the name was changed to Piety Hill. In about 1832, the name was changed to Birmingham by civic boosters with high hopes that the fledgling village would someday rival Birmingham, England, as an industrial dynamo.

Rail service to Detroit came in 1838 (the tracks were extended to Pontiac a few months later), and Birmingham soon had foundries, blacksmith shops, tanneries, and brick-making companies.

Next came a newspaper, banks, and professionals such as lawyers and doctors. By 1896, Birmingham had its own fire department, and the new Detroit United Railway (also called the interurban) linked Birmingham with the entire continent.

In the early years of the 20th century, hopes that Birmingham would become an industrial center of any consequence were completely and forever dashed as Detroit and nearby Pontiac became world centers of automobile production. Fortunately, in the 1920s, Birmingham began to establish itself as a premiere residential community. It had gas and electric power and a good water supply. Its schools were highly regarded. A wide range of business establishments served the needs of its residents. It was close to Detroit as well as the beautiful lakes and rolling meadows of Oakland County.

Families looking for a new life far from the crowds and clamor of the city began coming in greater numbers. The exodus from Detroit was fueled at least in part by the mobility of the automobile. Ironically among the newcomers were many automobile executives drawn by Birmingham's growing stock of estate-size homes and, perhaps, a simpler way of life reminiscent of days passed.

As more and more affluent residents arrived, so did business owners and shopkeepers eager to please them. Birmingham's population was 3,690 in 1920. By 1930, it had nearly tripled. In 1933, Birmingham became a city, with seven city commissioners who bickered, were unbelievably petty, and had personal agendas—just like today!

Although the Great Depression took its toll on the community (the First State Savings Bank failed in 1931), Birmingham's destiny had been determined. It would always be a residential town associated with the well-to-do members of society.

Today Birmingham's reputation as an affluent, trend-setting town—at least by sensible midwestern standards—is unchallenged. But curiously, Birmingham's decidedly middle-class core is largely ignored when labels are applied. However, Birmingham is a town where modest ranches, bungalows, and craftsman-style kit houses outnumber architecturally superb Tudors, elegant center-entrance Colonials, and brash "bigfoot" behemoths that contribute to Birmingham's ritzy—and sometimes ditzy—reputation. It is still a town where neighbors talk across the hedge, Indian Princesses march in parades, and seniors meet at the local coffee shop to solve the world's problems—just like hundreds of other small towns flung out across the map.

Birmingham's story is not unique. But it certainly is not typical, because Birmingham is not a typical town. It is a vivid example of the changing face of many American communities as we venture into the 21st century. Some communities have failed; some have struggled. Birmingham has prospered.

This book does not chronicle every event in Birmingham's history. Instead it is an attempt to show where Birmingham has been and provide a hint at the direction it is heading. On these pages you will see Birmingham's transformation from a pioneer settlement to a modest village, to a bustling town, to a premier community that symbolizes, at least for some, the fruition of the American dream.

One

OUT OF THE WILDERNESS

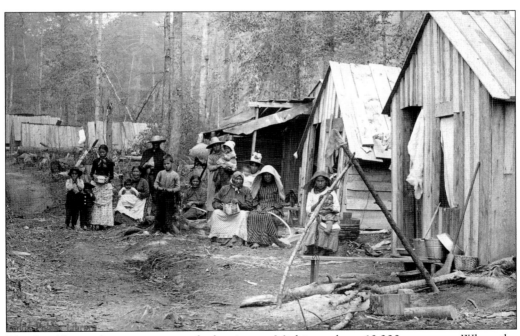

The first Native Americans entered what is now Michigan about 10,000 years ago. When the French explorers and missionaries arrived in the late 1600s, perhaps as many as 15,000 Native Americans lived here. The major tribes included the Sauk, Fox, Ojibwa (also known as Chippewa), and Potawatomi, shown here. All of the Native Americans spoke Algonquin dialects. The location of this Potawatomi reservation is unknown. (Grand Rapids Public Library.)

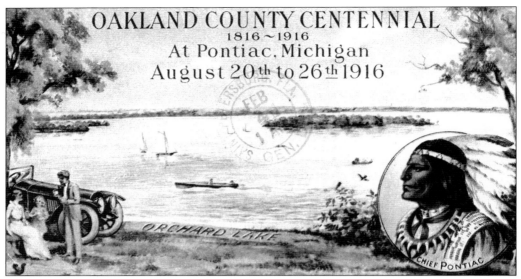

OAKLAND COUNTY CENTENNIAL
1816~1916
At Pontiac, Michigan
August 20th to 26th 1916

CHIEF PONTIAC

Oakland County must have seemed like a sylvan paradise to Native Americans who settled here. With 400–500 lakes and many streams, the area was ideal for hunting, fishing, and agriculture. Early settlers found remains of agricultural enterprises in the area, including cornfields near Rochester on the south bank of the Clinton River. State archeologists have found evidence of Native Americans in Birmingham as far back as 1,000 years ago.

The first surveyors who came to Oakland County found the land inhospitable. A swamp that included a portion of Royal Oak was a major impediment to development. Because the Potawatomi trail that meandered from Detroit to Pontiac was impassable for wagons, early Birmingham settlers such as John Hunter traveled from Detroit to Mount Clemens, and then westward along the Clinton River toward what is now Birmingham.

In the 1700s, many trails created by Native Americans crisscrossed southeastern Michigan. The Saginaw Trail linked Detroit to Pontiac. It was used by the Potawatomis to carry their furs to Fort Ponchartrain on the Detroit River and return to their villages with trade goods. Later they used the trail for their semiannual journeys to Detroit to receive government annuities as part of various treaties.

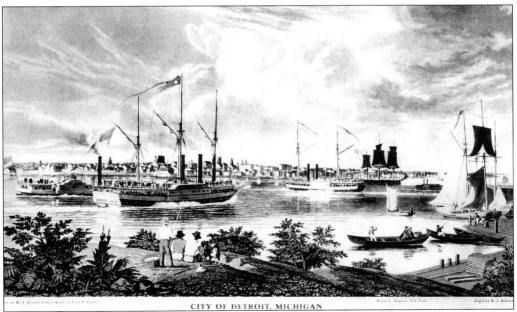

CITY OF DETROIT, MICHIGAN

The Detroit River was a busy waterway in the early 1800s. Many of southeast Michigan's earliest residents came overland from western New York and New England and then traveled by boat across Lake Erie to Detroit. Pioneers often named their new settlements after the towns they left behind, such as Troy, Rochester, and Utica. The number of arrivals increased with the completion of the Erie Canal in 1825.

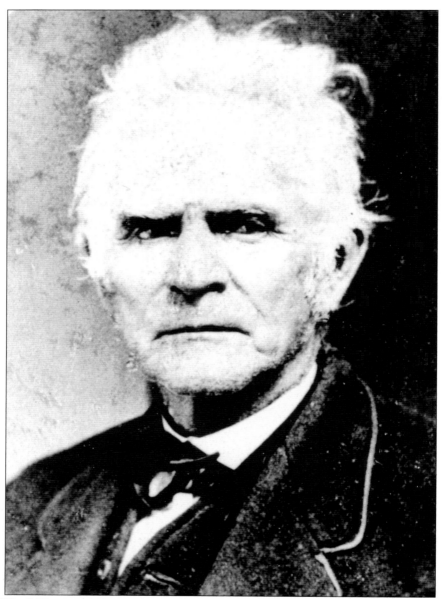

John "West" Hunter (1793–1880) was the first to settle what is now Birmingham. He and his brother Daniel came from Auburn, New York, and arrived in Detroit in March 1818. As a veteran of the War of 1812, he was entitled to buy land in the Michigan territory for about $2 per acre. On December 2, 1818, Hunter bought 160 acres. The parcel was known as Section 36 of the Township of Bloomfield. The following year, John and Daniel were joined by their father, Elisha, and the rest of the family, who sailed from Buffalo to Detroit on the small schooner *Neptune*. In January 1819, the Hunters built their first log cabin in about 10 days. Unfortunately, they built it on Elijah Willits's land and had to build another. In 1821, the Hunters were one of only four families in Oakland County. John, known as "West," opened a blacksmith's shop and foundry in 1828. This is one of two known photographs of John, who spent his later years in Waterford Township and is buried in Birmingham's Greenwood Cemetery.

One local legend involves an old French fur trader known only as Michaud. He told early resident Edwin Baldwin that in the late 1700s, he had come across a fresh battlefield littered with the bodies of dead Native Americans. Michaud said the battle occurred alongside a winding river north of the future town. If a battle of any consequence actually took place, the site may have been north of Greenwood Cemetery.

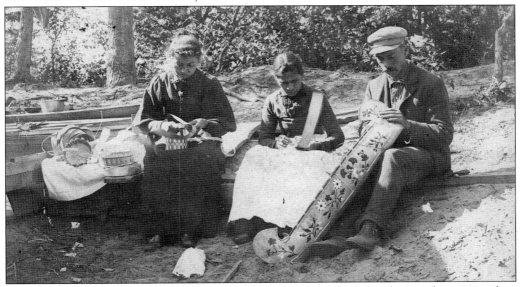

By the time the early settlers arrived, many Native Americans had already signed treaties ceding land and left the state. Others lived on reservations such as Potawatomi chief Seginsiwin's Village on the Rouge River, which survived until 1827. It was bordered north and south by what are now 12 Mile Road and 11 Mile Road, and east and west by Lahser Road and Telegraph Road. (Grand Rapids Public Library.)

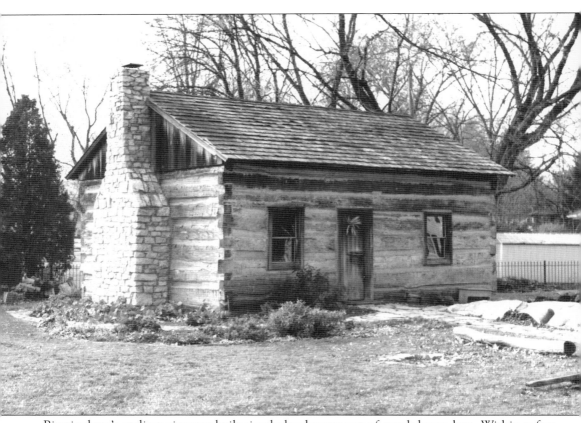

Birmingham's earliest pioneers built simple log houses out of rough-hewn logs. Within a few years, the log houses were replaced by frame houses. No photographs of any of the original three log houses built by John Hunter, Elijah Willits, and John Hamilton exist. The cabin pictured here is located at the Troy Museum and History Village. It was built in the 1840s in Frenchtown Township near Monroe and moved to Troy in 1982. The Birmingham pioneers' log houses were probably very similar to this one. Windows were a luxury often added after the settlers got established. The houses of Birmingham's first three settlers were located a day's journey from Detroit. They all opened taverns to service the increasing number of travelers on the Saginaw Trail. At first the outpost was known as Hamilton's and, later, Piety Hill.

The boundaries of Elijah Willits's 160-acre tract were Maple Road on the south, Pierce Street on the east, Oak Street on the north, and Lakeview on the west. Born in Pennsylvania, Willits was captured by the British in Detroit in the War of 1812. He came to Birmingham in about 1820 and built a log cabin on the west side of Old Woodward Avenue, near the intersection of current-day—no surprise here—Willits Road.

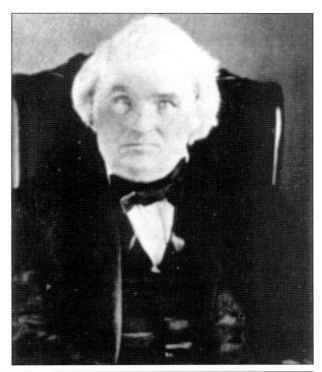

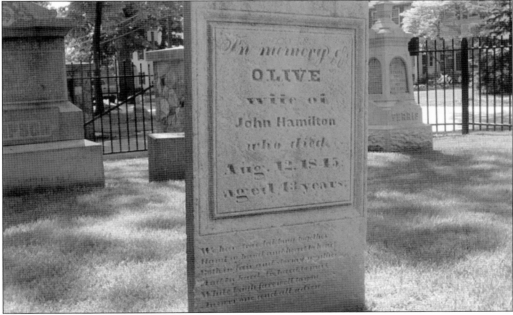

John Hamilton was born in Berwick, Maine, in 1790. He served in the War of 1812 and came to Detroit in 1815 while still a soldier. Hamilton was a bachelor when he purchased his parcel and built his log house on the east side of Old Woodward Avenue just north of Maple Road. Hamilton married Olive Prindle, sister of John Hunter's wife, Margaret, in 1819. She is buried at Greenwood Cemetery.

After discovering he had built his log house on Elijah Willits's land, John Hunter built a second home on the west side of Old Woodward Avenue, south of Maple Road, in 1822. Carpenter George Taylor worked on what was the first frame house in Bloomfield Township. In 1830, 12 people lived in the tiny house, including three workmen and the local schoolteacher, Mary Ann Beardslee, who lived in the front room upstairs.

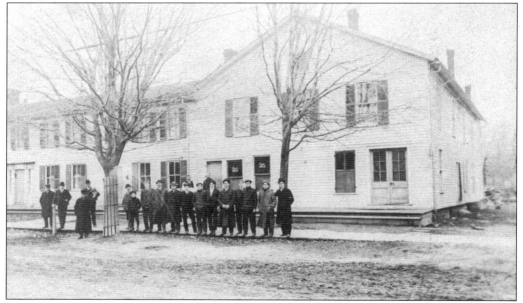

John Hamilton became an innkeeper and by 1827 had constructed the first frame tavern in Bloomfield Township. Later the inn became part of the National Hotel. Hamilton also operated a business transporting settlers and goods across the area using his own teams of horses and oxen. Ever industrious, Hamilton had 16 children by three different wives.

The story behind Birmingham's Greenwood Cemetery sounds like an urban legend, but it is true. In 1825, John Utter, his wife, Polly, and daughter Cynthia Ann lived north of town on the Saginaw Trail. In a state of derangement, the Utters' boarder Imri Fish, who was mentally disabled, killed the two Utter women with an axe. Following the incident, Dr. Ziba Swan provided a half-acre of his land north of town for a community cemetery.

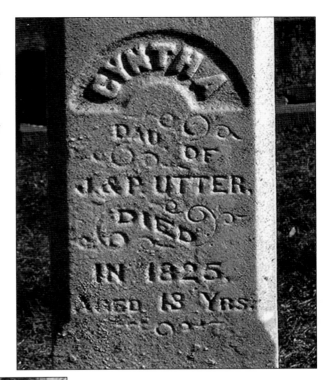

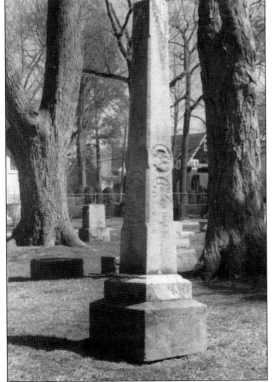

Today this is the southeast section of Greenwood Cemetery that runs along Oak Street from the eastern fence to the middle drive. John Utter died in 1827 and was buried with his wife and daughter in the cemetery. The three graves are marked by a single obelisk. Fish died in Pontiac in 1830 while serving time for the crime.

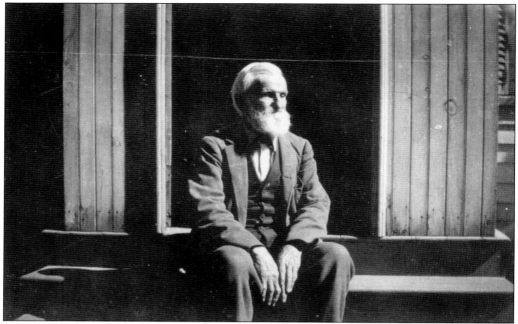

John Bodine was born in 1815 in Baptistown, New Jersey. He came to Birmingham in 1855 and opened a clothing shop. Nobody messed with Bodine, who was justice of the peace for 16 years. He also served on the school board and was appointed the inspector of Birmingham's first village election.

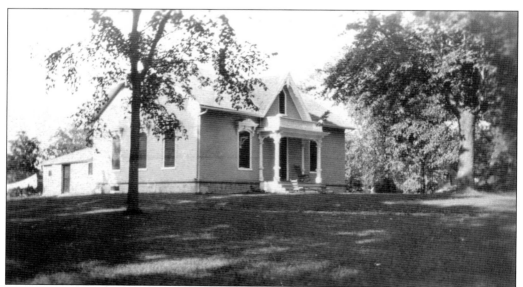

The redbrick schoolhouse was built in 1855 on land at West Maple Road and Southfield Road sold by Elijah Willits. Red was chosen for many schoolhouses because it was common, inexpensive, and did not show the dirt. This building served as Birmingham's elementary school until 1869, when the Hill School was built, and it was converted to a house and painted white. The historic Allen House now stands in the same spot.

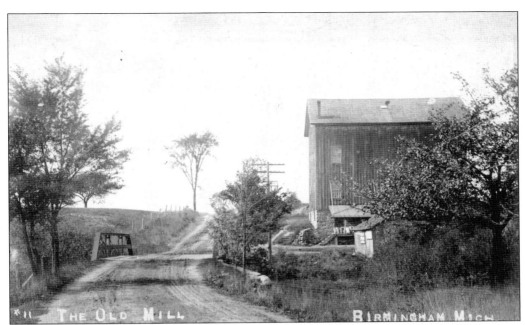

Several gristmills and sawmills were constructed in the Birmingham area in the 1820s to serve the needs of farmers and settlers. In about 1833, brothers Josephus Young and John J. Young built a sawmill west of Birmingham along the Rouge River. An earthen dam was created at the south end of a ravine to form a millpond (later called Quarton Lake) that would provide a source of waterpower. In 1835, Roswell T. Merrill of Birmingham bought the sawmill and converted it to a gristmill. Farmers from miles around brought their crops to the mill to be ground. The original millstone is still located in the grassy area north of the current waterfall.

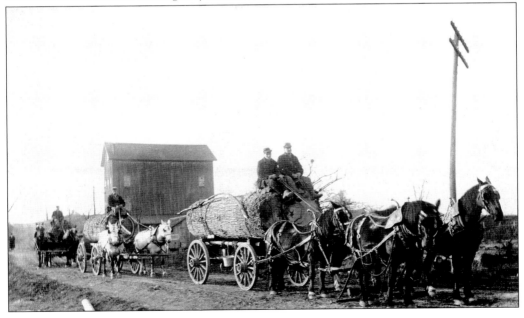

Dr. Ziba Swan arrived in Bloomfield Township shortly after the original three landowners. Originally from Connecticut, the 53-year-old Swan bought two sections of land (320 acres) north of what is now Oak Street. The area became known as Swan's Plains. The settlement's first schoolhouse was a one-room cabin on his land. The original one-half acre of land that Swan provided in 1825 for a cemetery is shown here.

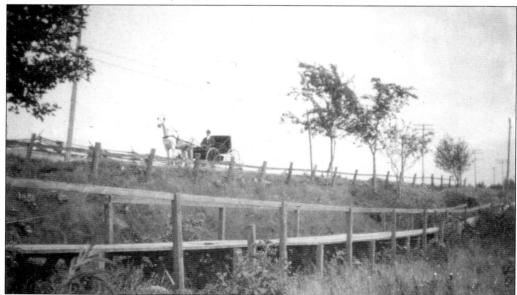

In the mid-1800s, the Saginaw Road connecting Detroit and Pontiac was a plank road. A toll had to be paid to its builders. One tollgate was located at the intersection of what is now Quarton Road and Woodward Avenue. This buggy shown alongside what is now Booth Park could be on its way to the cemetery, farms north of town, or Bagley's Corners, at what is now Long Lake and Woodward Avenue.

Dr. Ebenezer Raynale moved to Birmingham in 1839. Getting to his patients was rough in the early days. Dr. Raynale once traveled several miles into the country in a blizzard to help a very sick, poor woman. He nearly died himself on the way back home. Dr. Raynale was elected to Michigan's first state senate and led the expansion of Greenwood Cemetery. His son and grandson were also Birmingham doctors.

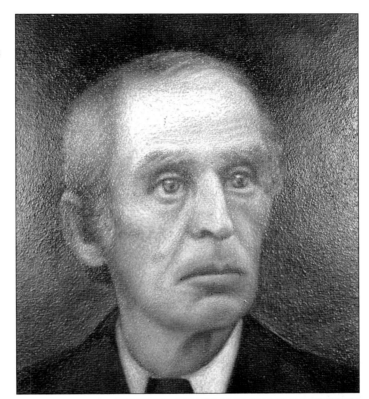

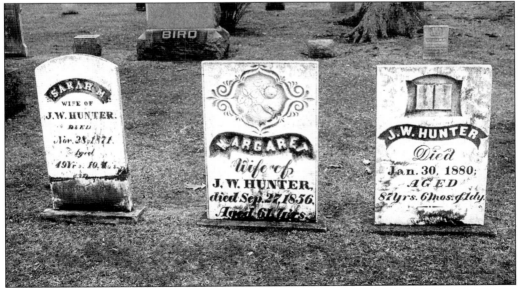

Many of Birmingham's pioneers are buried in Greenwood Cemetery. John Hunter is buried alongside his first wife, Margaret, and second wife, Sarah. Elijah Willits's 1868 headstone includes the simple words, "A founder of Birmingham." The graves of Birmingham Eccentric founders Almeron Whitehead and George Mitchell are located, fittingly, near each other. Civic leader Martha Baldwin is also among the town's leaders interred at Greenwood Cemetery.

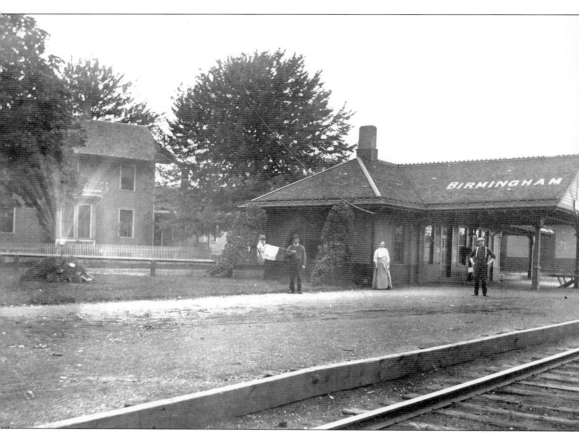

In the 1820s and 1830s, Birmingham and nearby Franklin competed to be the major hub in the area. Franklin's fate was sealed as "the town that time forgot" when the railroad chose Birmingham. The railroad was called the Detroit and Pontiac Railroad. The station was originally on the east side of Woodward Avenue (previously called Hunter Boulevard) at Maple Road. By the time this photograph was taken, the station had been moved to the west side of Woodward Avenue. The railroad was called "the Huckleberry Line" because it was so slow that passengers could easily jump off the first car, pick their fill of huckleberries, and jump back on the last car. A train was quite a novelty in those days, and people came from all over the area to gawk at it. The train made it easier for farmers to get their goods to market and made travel to Detroit and Pontiac much faster. The frontier days were over.

Two

A GROWING VILLAGE

The village of Birmingham was surrounded by pastoral farmland. At one point, Oakland County had 32 mills using waterpower to grind grain into flour and operate machinery. As late as 1870, 35,000 of the county's 40,000 people were still living on farms. The county was a leading producer of wheat, potatoes, wool, cheese, butter, pork, and apples.

The Hall family farm was located on 87 acres at Maple Road and Adams Road and dates back to 1840. The farm had a horse barn, a cow barn, pigpens, a henhouse, a large corncrib, and a farm implement house. Adams Road is in the foreground in the photograph above.

In the early days, the Hall farmhouse at the southeast corner of Maple Road and Adams Road was on the edge of town. The Hall Farm was purchased at auction in 1898 by Joseph and Clara Harris for $11,116.80, a good sum of money in those days. The farm was later subdivided and became the Birmingham Villas Subdivision. The house still stands but has been substantially modified.

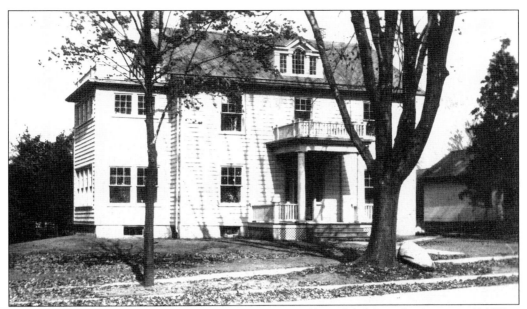

Birmingham's grand dame Martha Baldwin lived most of her adult life in this house at 484 West Maple Road. Her grandfather Ezra came from Vermont and built a cabin in Troy Township in 1819. Ezra's son, Edwin, married Aurilla Patrick in 1837 and had Martha, an only child, in 1840. The house on West Maple Road was built in 1860 when Edwin gave up on farm life. It still stands.

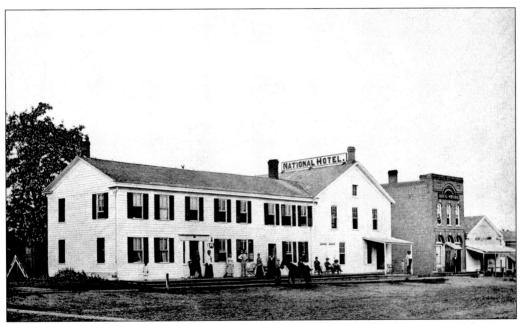

John Daines and later his son Ned operated the National Hotel. The elder Daines, like many other early settlers, had come to Birmingham from New York State. The National Hotel was the social hub of the area in the later 1800s, hosting dances and other events. In the 20th century, Prohibition contributed to its downfall.

The Blakeslees were one of the earliest families in town. Scriba Blakeslee came to Birmingham in 1823 from Oneida County, New York. His son George Blakeslee was part owner of the sawmill located on what is now Endicott Lake, just north of Quarton Road. George later owned a hardware store and supervised construction of the Hill School. George, Ann, and Frank Streets were named after his three children.

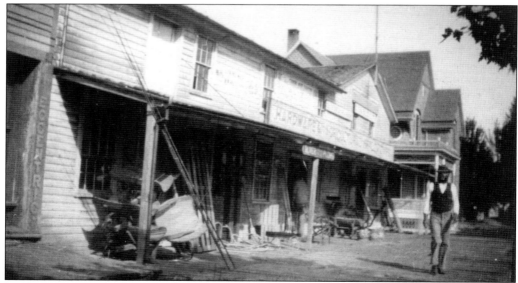

Hugh Irving owned a hardware store and lumberyard on the west side of Old Woodward Avenue north of Maple Road. It was torn down and rebuilt as Charles Schlaack's Hardware, and later, Huston Hardware. Irving's son William fought at Gettysburg and was killed in 1864 in the Battle of Spotsylvania Court House by a single bullet to the forehead. Hugh Irving traveled to Virginia to recover his body. After the war, he led the effort to build the Civil War Monument.

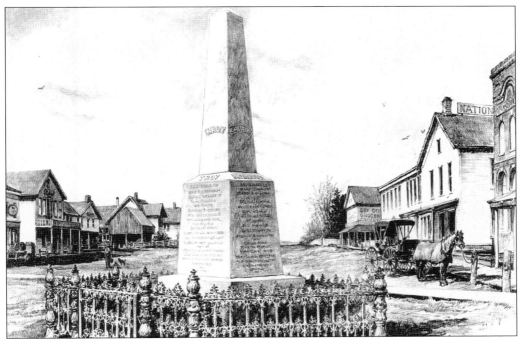

The Civil War Monument was dedicated in 1869. It was originally at the intersection of Maple Road and Old Woodward Avenue, but relocated to Greenwood Cemetery in 1900 because it interfered with traffic. The monument currently sits in front of the Birmingham Municipal Building and is the site of Birmingham's annual Memorial Day ceremony. More than 400 Oakland County residents died in the Civil War.

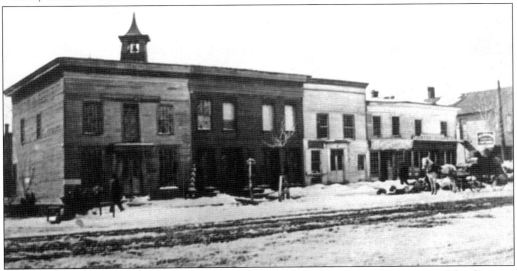

The United States Centennial was July 4, 1876. It did not matter that it rained buckets on that day, because no official celebration was planned. In fact, that April the village trustees had passed an ordinance prohibiting firecrackers, perhaps to keep the celebrating in check. They were not all party poopers back then: Ned Daines hosted his own centennial bash at the National Hotel.

Just prior to the Civil War, Daniel Stewart built his farmhouse at the corner of what is now Puritan and Maple Roads. Sometime around 1887, Stewart sold the house and 200 acres of land to Gilbert Watkins and his family. Watkins started the Watkins Pony Farm, importing and breeding the finest ponies from the Shetland Islands. The pony farm extended from Quarton Lake to Cranbrook Road.

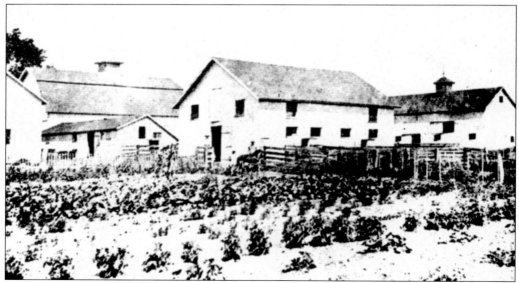

Marion Quarton Stecker's father, Fred Quarton, bought the Watkins Pony Farm in 1906. Stecker's recollections of farm life included sneaking out back to the chicken coop against her mother's orders, watching a big horse come to the well outside the back door for a drink, and the antics of a hired hand named Caleb who often took a snooze on a hammock by the barn after he had taken a nip.

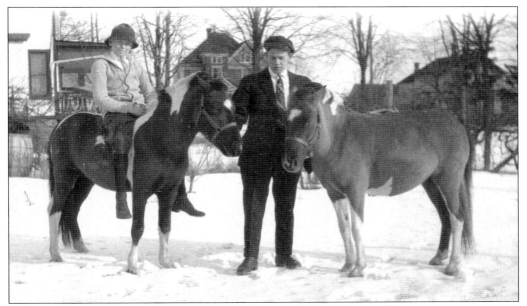

By 1893, Watkins had 100 head of award-winning Shetland Ponies. The ponies earned their keep by working summers at the Bob-Lo and Belle Isle amusement parks. Watkins hired young people each spring to drive the ponies down to the Detroit River where they were ferried to their summer jobs. Watkins sold off his land between about 1906 and 1915, prior to the area being subdivided to become Quarton Lake Estates.

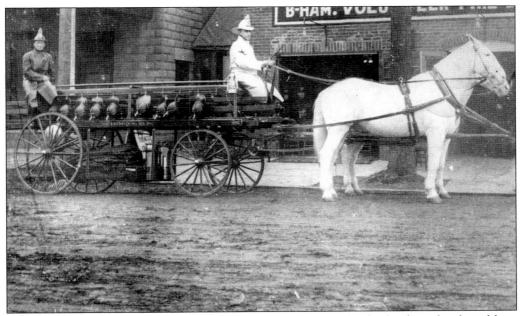

Fire was a major concern in the 1800s. Whenever a fire started, a bucket brigade of neighbors was enlisted to put it out. Almeron Whitehead recognized the community needed better fire protection and led the creation of an all-volunteer fire department. Chief Jim Cobb is sitting atop the wagon.

Birmingham's first high school was the Old Academy, established in 1860. It later moved to the second floor of a frame building at the southwest corner of Maple Road and Pierce Street. Kids from several miles around attended the school. Rev. Samuel N. Hill was the teacher. The building was owned by Civil War veteran Capt. John Allen Bigelow, who operated a general store and insurance business on the first floor.

In 1868, firecracker Martha Baldwin formed a literary club that founded the first library in Birmingham. It was located in the back of the Methodist church, which was at the northwest corner of Merrill Street and Bates Street and built in 1839. When the Methodists moved to a new church in 1873, the building pictured here became known as Library Hall. It also housed the Village of Birmingham and Bloomfield Township offices.

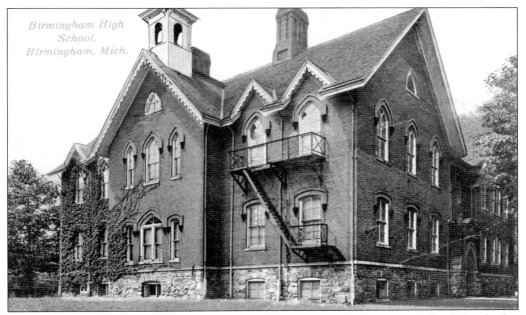

Birmingham High School, Birmingham, Mich.

After the Old Academy burned down in 1867, the community took action. Roland Trowbridge proposed that $12,000 be raised to build a new school for all students at the corner of Chester and Merrill Streets. The Union School was completed in 1869 and later renamed Hill School in honor of Reverend Hill, the instructor from the Old Academy.

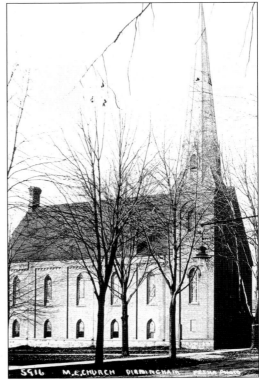

The new Methodist church was completed in 1873. It was located at the southwest corner of Maple Road and Henrietta and cost $20,000. The church had 141 members. In time, the congregation outgrew that building. In 1951, the property was sold to S. S. Kresge and the Methodists paid $25,000 for a five-acre parcel at Maple Road and Pleasant. The new church was completed in 1952.

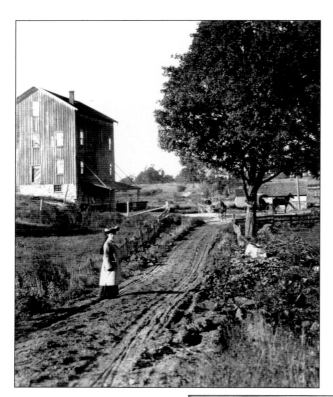

With the old gristmill behind her, Tilly Thurlby Rundel stands on the road that led to the Parks' Meat Market Slaughterhouse, which was south of Maple Road, just down from the mill. A horse-drawn buggy to the right of the tree is heading toward town.

Edwin O'Neal was a skilled leather craftsman who came to Birmingham in 1885. He opened a store in a one-story freestanding wooden building on the west side of South Old Woodward Avenue, where he repaired harnesses and reins for horses. In this photograph, O'Neal is at the far left. The frame structure was replaced by a brick building in about 1905.

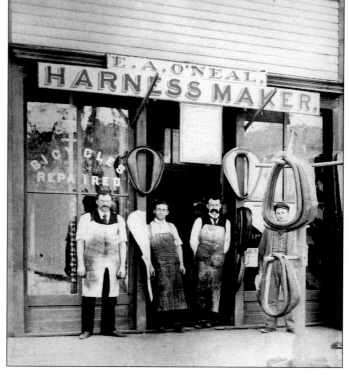

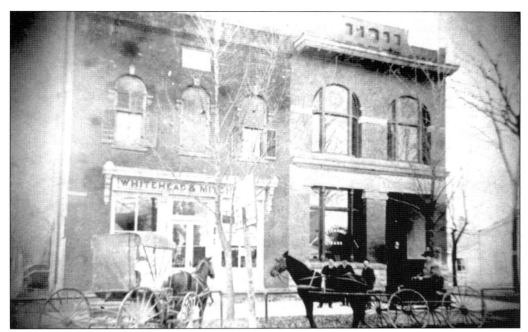

A Panoramic View of Birmingham, published in 1881, described the building on the southwest corner of Maple Road and Pierce Street as a "post office, express office, Masonic Hall, and the grocery of John Bigelow." Capt. John Allen Bigelow constructed the building in 1870. Shain's Drugstore occupied a corner of the building for more than 50 years.

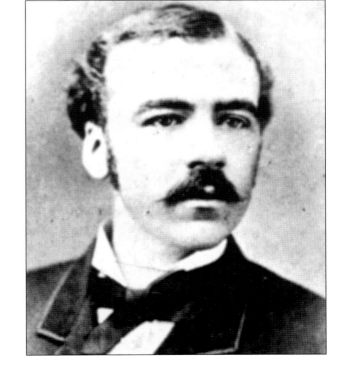

Almeron Whitehead was born on his family's farm near Elizabeth Lake in 1851. In 1870, he got a job clerking in Captain Bigelow's general store. He began his friendship with George Mitchell when they both were young clerks at the store. In 1877, Whitehead married Emma Bodine, daughter of Birmingham pioneers John and Sarah Bodine.

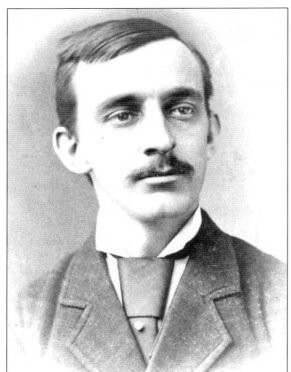

George Mitchell was born in Birmingham in 1854. His parents had come from New York in 1847 and ran a mercantile business on the west side of Old Woodward Avenue, opposite Hamilton. George and Almeron Whitehead's lifelong friendship included operating their own drugstore and founding both the *Birmingham Eccentric* newspaper and the Exchange Bank.

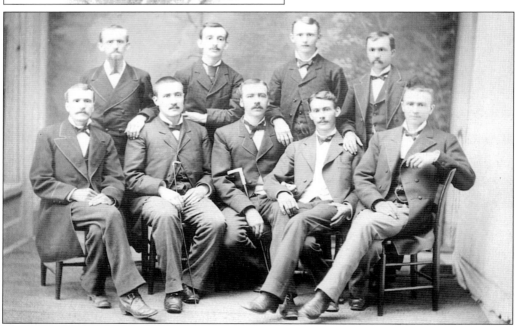

In 1875, Whitehead and Mitchell bought a printing press for $90. About three years later, they were ready to take a stab at publishing their own newspaper to compete with the *Birmingham Post*. At the time, the two men were in a social club they called the Eccentrics Club, which was a reference to the Jules Verne novel *Around the World in 80 Days*.

The Eccentric.

VOL. 1, NO. 1.　　　BIRMINGHAM, THURSDAY, MAY 2, 1878.　　　PRICE, TWO CENTS.

C. W. JENKS,

Dealer in Coffins, Caskets, and all goods generally sold by undertakers, repairs furniture. Also agent for the Sweepstakes Threshing Machine, and other agricultural implements.　1

OWEN SWAN,

Birmingham, Mich., can cure the following diseases by his new method: Coughing, Driving on One Rein, Shying, Pulling, Balking, Running at the Eyes, Slovring, and all diseases caused by imperfect mastication.　1

J. BALDWIN.

Blacksmith. Horse shoeing done cheap, and in a first-class manner. Repairing of all kinds done at short notice.　1

WM. H. CAMP

Will attend auctions at any time and place, on short notice. Terms reasonable. Horse and Cattle Farrier.　1

FRED. R. LAMB.

Plain and Ornamental Painter. Painting, graining, gilding, varnishing, kalsomining, wall tinting and paper hanging.　1

MRS. L. T. FURMAN,

Birmingham, Mich., has just received a new stock of summer millinery; also a fine line of fancy goods, hair goods, zephyrs, etc. No trouble to show goods.

Eccentricities.

Now slaughter the weeds in that bean garden.

Hugh Irving's new residence is progressing finely.

John Bodine intends giving his house a coat of paint.

No fears need be entertained of a severe drought this month.

Let the dear old hen set if she wants to. What's a hen's time?

Miss Hattie Hall left home last week to teach at Eaton Rapids, Mich.

A five year old son of George W. Brayman's is quite sick with a high fever.

We shall be pleased to hear more from "Rastle," on any subject, at any time.

Commercial travelers, more commonly known as "drummers," are very plentiful.

Subscribe for THE ECCENTRIC before you forget it. Fifty cents per year in advance.

Just think! A paper containing the local news of Birmingham and vicinity, one year for fifty cents.

Mrs. Sarah Parks, of Troy, who has been dangerously ill for some time past, is said to be improving.

Lyman has been fishing—caught a shiner—hangs it in the breeze from his front steps.

Rev. Thos. Middlemis moves into the house formerly occupied and owned by M. M. Toms, as soon as a few repairs and general fixing up are completed.

Miss Anna Hall, teaching in the Todd District, was compelled to give up her school on account of a severe cold, but will resume teaching as soon as she is able.

A five year old son of J. S. Cannon, of Southfield, had his skull fractured by a binder accidentally thrown from a wagon, and striking him upon the head.

We notice James Webb, of Pontiac, in our midst, and learn he has the contract for plastering the new houses of George Shane and H. J. Bloomburg, on Mill street.

Trees, etc., were delivered, last Friday, by Bixby & Proper, from the well known house of E. C. Peirson, Waterloo, N. Y., known as the Maple Grove Nurseries.

Mrs. R. D. Losted and daughter, visiting I. & M. Lowes, intended to have started for home last Saturday, but on account of Dollie's being very sick, the return was postponed.

All communications must be addressed to THE ECCENTRIC, Birmingham, Mich., and must have the writer's name attached; otherwise they will be consigned to the waste basket.

Specie payment resumed! Prof. Webster

Mattie Baldwin has had built a bird house complete in every respect, bay windows and all, for the accommodation of "our birds," and for the pleasure and entertainment of "our folks." She has purchased and has at home a new piano.

No matter how much you may delve and dig and spruce things up, the wife of the next man who occupies your house will say, "It isn't fit for hogs to live in," and will go right to work to make it so. What a comfort to an over-neat housekeeper!

Mr. and Mrs. McAllister Randall, of Dundee, Mich., drove over and made their hearts of friends happy by remaining a week, making a short visit to all and returning by same conveyance. On his return Mc. starts on the road selling goods for the well known tobacco house of K. C. Barker & Co., of Detroit. Success to you. Mc.

Peter Day, Sr., an early settler of Troy, lies at the point of death, suffering from a complication of diseases, namely, rheumatism, heart disease and erysipelas. Mr. Day is in his seventy-ninth year, and has been a resident of Troy township forty-six years, living in one place the whole period with the exception of one year.

Our friend, G. Frank Allen, who went to Sault Ste Marie to take charge of a bakery at that place, returned by next boat.

On May 2, 1878, Whitehead and Mitchell printed the first edition of their paper from the second floor of what is now called the Bigelow-Shain Building at Maple Road and Pierce Street. They christened their paper the *Birmingham Eccentric* to recognize their social club. The newspaper's offices later moved to the building just south of the Bigelow-Shain Building on Pierce Street.

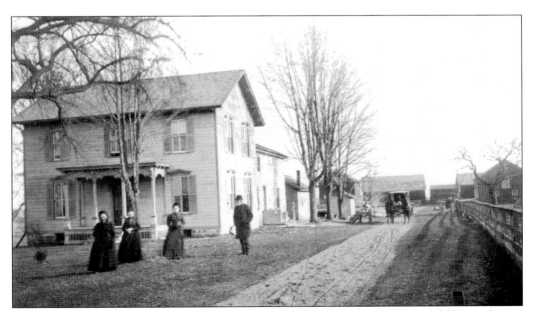

Thomas and Mary Quarton were married in England and moved to Bloomfield Township in 1882. They lived on a 160-acre farm on Quarton Road. The original farmhouse at 1155 Quarton Road was built in 1838. It has been significantly modified, but it still stands. Pictured are, from left to right, Eliza Wallace, Mary Quarton, and Mr. and Mrs. Lyman Peabody.

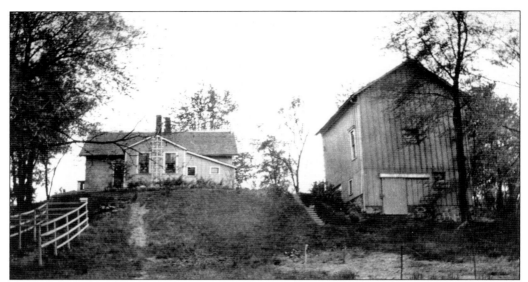

After Hill School was built, Horace Randall bought the redbrick school on Maple Road. He remodeled it in 1879, installing a new water heater and commercial icebox. Outside Randall had an enclosure where two pet deer lived. This undated photograph was taken from Willits Road and shows the back of the property.

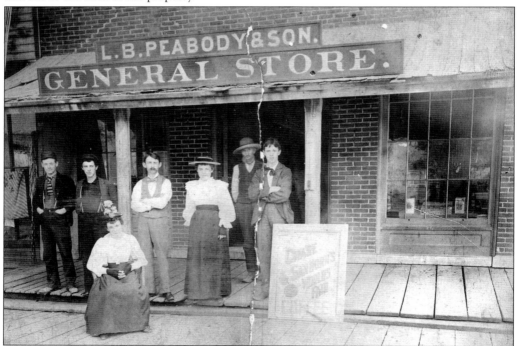

Lyman Peabody's General Store was located at the southwest corner of Maple Road and Old Woodward Avenue. J. Bert Peabody, wearing the vest, was Lyman's son. When J. Bert Peabody married the well-to-do Alta Ford, the couple moved into the Ford-Peabody Mansion and J. Bert's working days were over. Note that the Lyman Peabodys were distant relatives of the Peabodys who farmed land on Gilbert Lake and later opened a grocery store on Woodward Avenue.

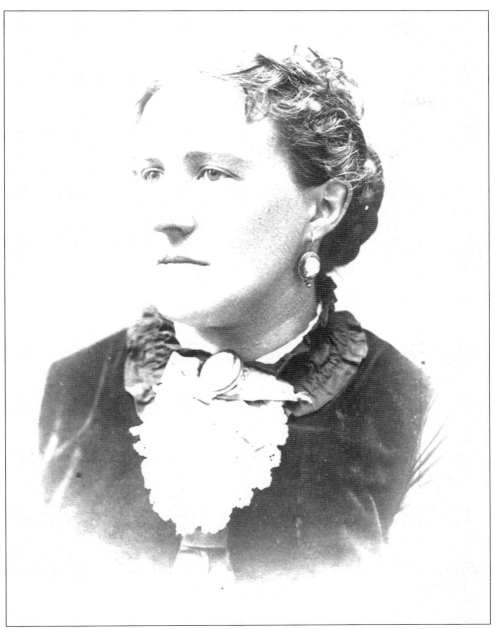

Martha Baldwin (1840–1913), also known as Mattie, was a crusader, gadfly, suffragette, and tireless worker for the Village of Birmingham. She was the driving force behind the city's first water system, led the town's campaign to clean up the village cemetery, and contributed the land that is now Martha Baldwin Park. Baldwin's most enduring gift to the city is the public library that bears her name. In 1868, Baldwin formed a small literary club. The women held every kind of fund-raiser imaginable and purchased the original Methodist church at the corner of Chester and Bates Streets for Birmingham's first library. When more room was needed, Baldwin led the Ladies Literary Association's purchase of land at the southeast corner of Maple Road and Old Woodward Avenue. Her name lives on today all over town.

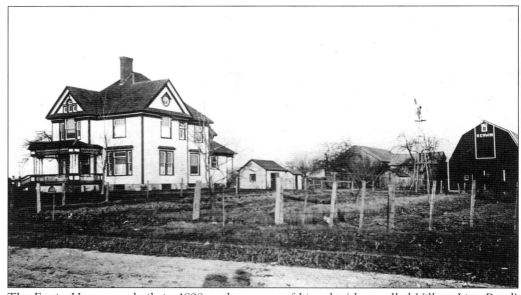

The Erwin House was built in 1898 at the corner of Lincoln (then called Village Line Road) and Southfield Road. Original owners Richard and Flora Erwin's descendants lived in the house until 1950. Current owners Tom and Susan McDaniel have learned that the house was built in just four months at a cost of $1,425 and that one of the Erwin daughters eloped from an upstairs window.

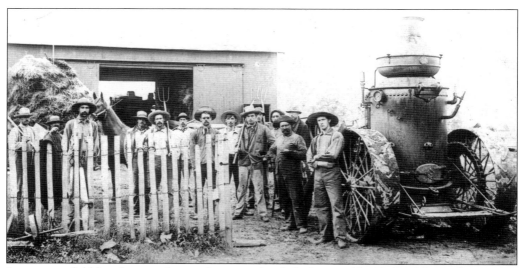

In autumn, field hands came from miles around to help farmers like Richard Erwin harvest his crops. A separator, powered by a steam traction engine, was used to separate grain from straw. The Erwin Farm also had a dairy that sold milk in large quantities. In 1916, the Erwins' 80 acres was platted to create the Crestview Subdivision.

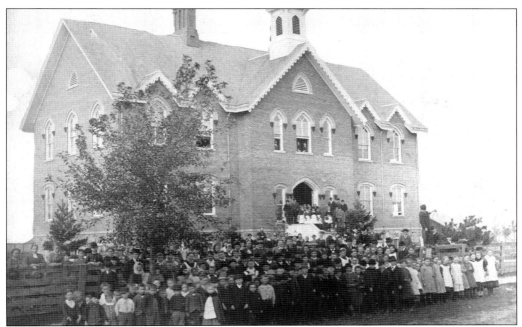

Hill School accepted students from the countryside all around Birmingham. In the early days, some students came on horseback or two or three to a carriage. Mrs. Harry Allen later remembered, "There was a big barn across Martin. They used to pay ten cents a day to put their horses in the barn to keep them out of the weather."

In the 1880s, Almeron Whitehead and George Mitchell owned the only safe in town. When a well-to-do lady visiting Birmingham needed a safe place to store her valuables, Whitehead and Mitchell let her keep them in their safe. Later farmers who had just sold their produce at the railroad depot asked the two to keep their money in the safe. The service ultimately became known as the Exchange Bank.

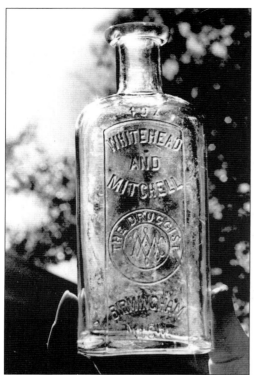

Almeron Whitehead and George Mitchell dabbled in many areas. This apothecary bottle, from Whitehead and Mitchell's drugstore, has somehow survived. It is not known if the bottle was used to fill a doctor's prescription or for an elixir that the two men bottled on the premises themselves, such as a beef, iron, and wine tonic.

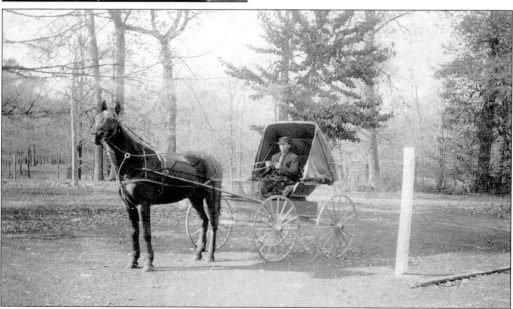

In the late 1800s, the lower part of the village near what is now Stanley and Brown Streets was the tough part of town, and brawls were a common occurrence. Town marshall Nick Mooney was often called to break up the fisticuffs and haul the scofflaws off to the jail in Pontiac. The photograph above shows a young James Anderson, who became Birmingham's police chief in 1926.

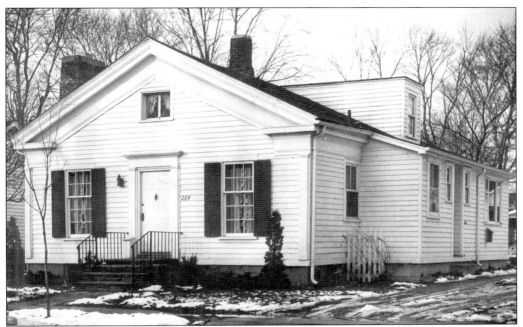

The Hunter House passed through several owners in the 1800s. In 1893, it was purchased by Alex and Anna Parks. They planned to tear it down and build a Victorian mansion on the site. However, Henry Randall bought the house that same year and moved it to 264 West Fremont Street, now Brown Street. The house had an outhouse in the backyard. A spring in the basement provided water.

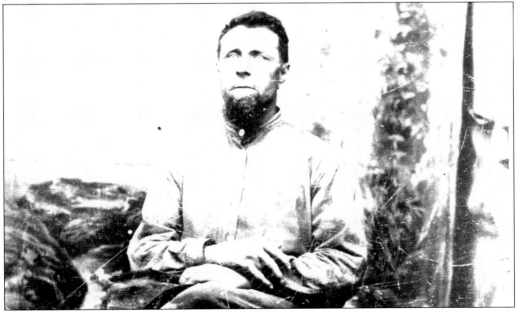

Randall was born in 1840 and married Martha Brown in 1859. Randall fought with the 24th Michigan Volunteers in the Civil War and lost a finger on the first day of the Battle of Gettysburg. Randall lived in the Hunter House until he died in 1903. Martha died in the house in 1914.

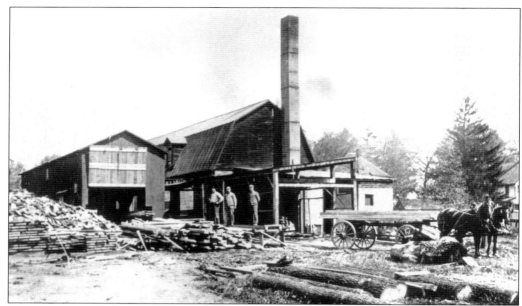

The W. E. Smith Milling Company was located near the southwest corner of Maple Road and Woodward Avenue, alongside the railroad tracks. In the 1900s, farmers came from miles around to purchase lumber and planks, feed for their cattle and poultry, and flour to make bread. The mill later became Peabody's Market.

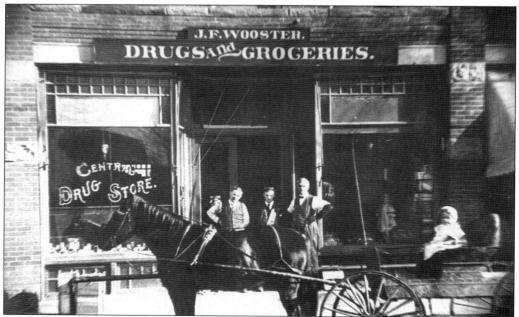

Jim Wooster operated a grocery and drugstore on the east side of Old Woodward Avenue, north of Maple Road. One odd little story about him survives: the day after he was elected to village office, Wooster was passing out cigars to his supporters when a stranger came into the store. Wooster asked the man, "Would you like a cigar?" The man replied, "No, but I'll have a bottle of ketchup."

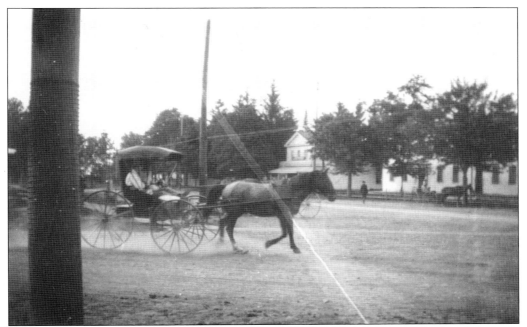

One night in 1883, neighbors heard an intruder at Poppleton's General Store. Edgar Poppleton went to check it out. He found broken windows and heard rustling inside. "Halt," he shouted to the intruder. A gunfight ensued. Poppleton was grazed on the ear but shot the intruder three times. The intruder died that night at the National Hotel. Half the men in town went there and gawked at his body.

The Mose Taber House was built by John Jones in the 1870s. It was located at the southwest corner of Old Woodward Avenue and Merrill Street. The house's design was Italianate, a style popular between 1840 and 1885. It is believed that at one point the house was used as a private gentlemen's club. Exactly what type of socializing was conducted at the private gentlemen's club remains a mystery.

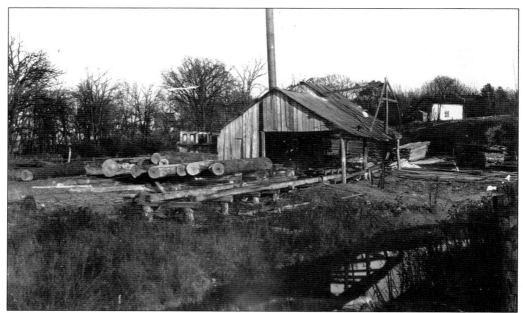

The legendary Ty Cobb may have swung a baseball bat produced at James Zimmerman's mill between 1890 and 1905. Zimmerman's factory was located at Maple Road and Baldwin Road, alongside the Rouge River. Using steam power to turn the lathe, Zimmerman also made axe handles, tennis rackets, pole vaults, and other wooden goods.

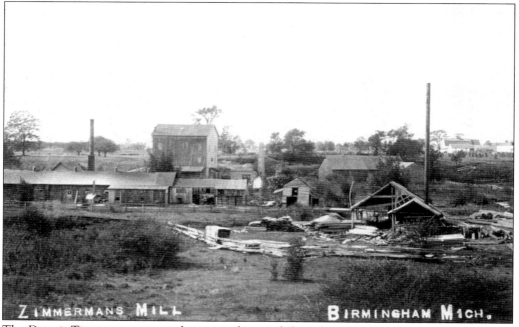

The Detroit Tigers were among the teams that used the "Zimmerman Lifter," which was made of ash. Zimmerman moved his company to Owosso in 1905, and continued making bats until the 1920s when his company was bought out by Louisville Slugger. The Birmingham mill Zimmerman left behind remained idle for many years until it was finally torn down.

Three

HUB OF COMMERCE

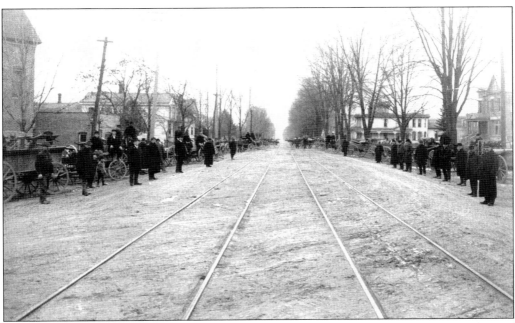

The 1877 History of Oakland County described Birmingham as "a most agreeable place of residence." The village was surrounded by farmland, and people traveled primarily by horse and carriage when this photograph looking south down Old Woodward Avenue was taken in about 1900. In just a few years, the isolation of rural life would change when the automobile brought people much closer together. The reason for this gathering is unknown.

This primitive photograph provides a good view of the intersection of Maple Road and Southfield Road at the dawn of the 20th century. The property was an unsightly gravel pit owned by the Baldwin family. The rock in the middle is known as Martha Baldwin's hitching rock. Whether she actually hitched her horse to the rock is not known.

Baldwin was not one for knitting—she was always on the go. Whatever the weather, she hitched up her buggy and made her daily rounds, which consisted of picking up litter and making sure the village was in good shape. Cleaning up the village cemetery, which had been neglected following the death of Dr. Ebenezer Raynale, was one of her projects. Baldwin was buried there herself in 1913.

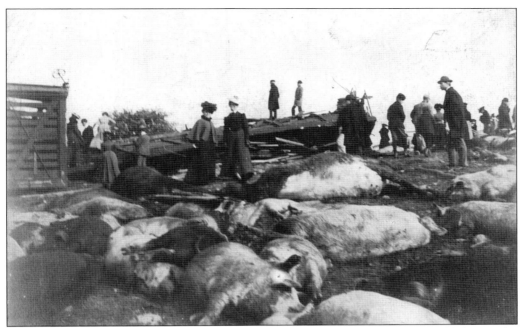

During a night run on October 18, 1901, two freight trains collided in a farmer's field three miles north of Birmingham. The three crew members on the northbound locomotive were killed. The crew of the southbound train survived by leaping from the train moments before impact. The remains of hundreds of pigs and cattle being transported to market were scattered on the crash site, which was visited by many fashionable gawkers.

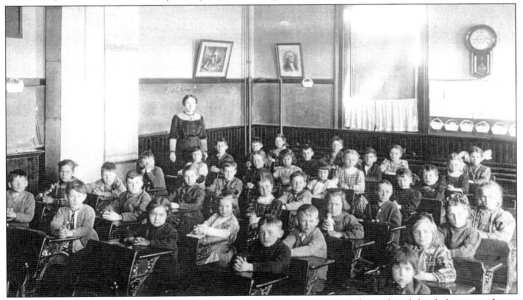

David Bemis was Hill School's principal in the early 1900s. The school had four teachers, including Miss Hanna, whose eager second-grade class is shown in this undated photograph. Tuition for children who lived outside Birmingham was $5 a term. The Hill School building later served as the Birmingham school district's administration building. It was razed in 1969.

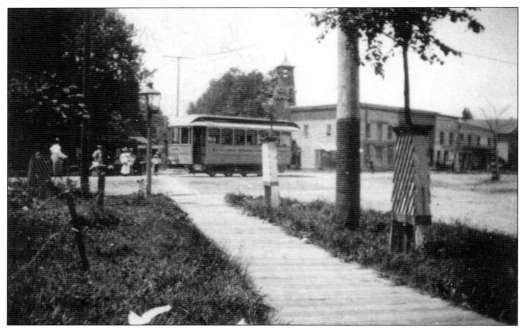

The new electric interurban railway changed life in Birmingham forever. Founded in 1896 as the Oakland Electric Railroad, the railway was known to everyone as the interurban. It connected the Palmer Park area of Detroit to Birmingham and, later, with Pontiac. The cars clipped along at 40 miles per hour. The interurban later became part of the Detroit United Railway (DUR), which was a consolidation of several interurban lines.

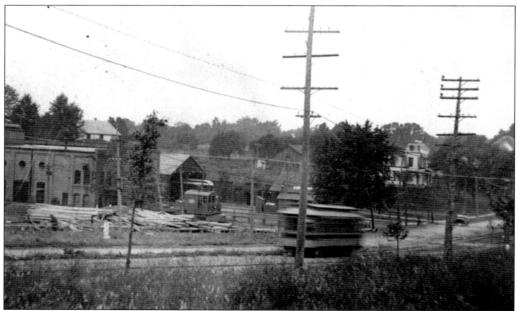

The interurban's powerhouse was located at the current site of Booth Park at Harmon Street and Old Woodward Avenue. A separate spur line brought coal to the plant. The coal-powered stationary steam engine powered the generator that provided electricity to the cars.

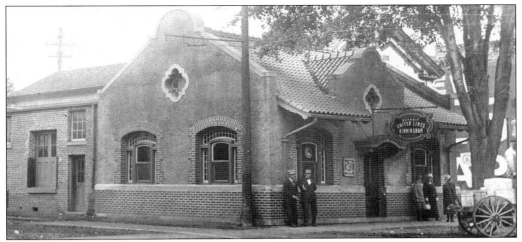

The DUR Waiting Room was built in the early 1900s on the west side of Old Woodward Avenue between Maple Road and Merrill Street. The front part of the building included a ticket office, soda fountain, and newsstand. Freight carried by the DUR was stored in a rear room. Olga's Kitchen occupies this location today.

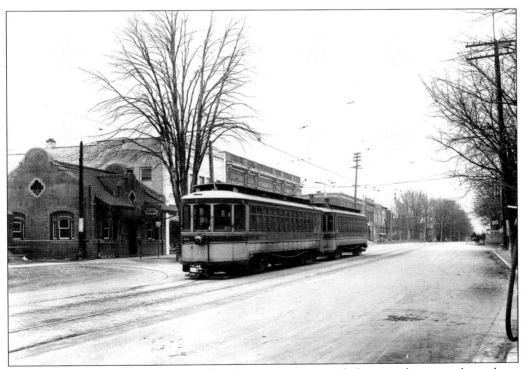

The interurban usually had two cars. The first car was motorized; the second was a trailer without power. Both cars were heated with coal stoves that seldom gave out much heat while the vehicles were moving slowly through Detroit traffic. However, as soon as the cars picked up speed in the relatively open country north of Six Mile Road, there was plenty of draft to fire the coals.

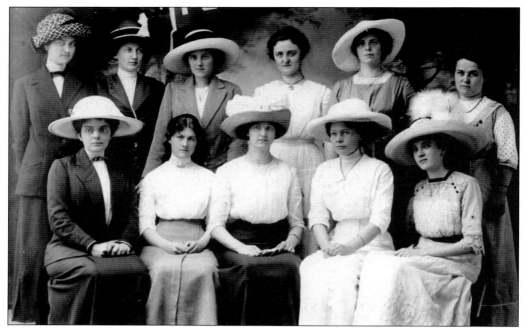

Put-in-Bay was a popular summertime tourist destination at the beginning of the 20th century. Starting June 1 each year, the elegant steamer *Put-In-Bay* made daily runs to the Ohio resort, leaving Detroit at 8:30 a.m. and arriving at Put-In-Bay at 12:45 p.m. This group of elegant Birmingham women was photographed in about 1900.

Dirt roads in the early 1900s were a constant nightmare. If they were not muddy or icy, they were a dusty mess. East Maple Road became the first street in the village to receive a dust treatment in 1910, when John Heth organized his neighbors to treat the road with more than 100 barrels of calcium chloride at a cost of $4 per barrel. Most neighbors contributed $2.

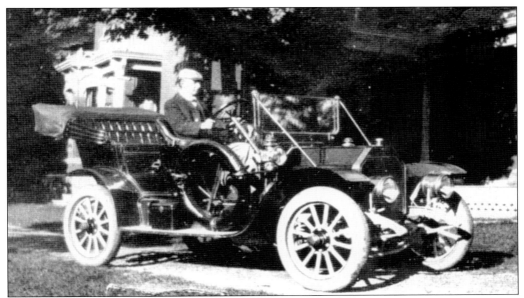

In the spring of 1900, the *Birmingham Eccentric* reported a strange new contraption on the streets of town when the first automobile passed through Birmingham on its way to Pontiac. By 1902, so many automobiles were whizzing through Birmingham that the village fathers passed a speed limit of six miles per hour. Pictured above is J. Bert Peabody in his first Buick, perhaps in the driveway of the Ford-Peabody Mansion.

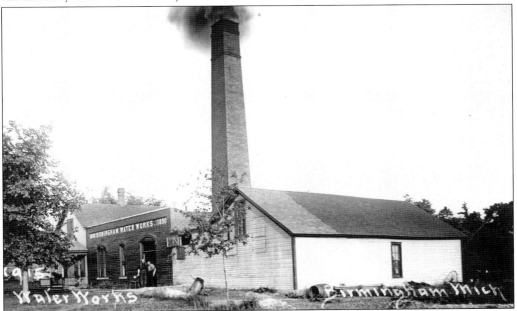

For most of the 1800s, unsanitary and unreliable underground wells were the major source of water for the town. In 1890, the Birmingham Water Works was created. A plant was built on the south side of Maple Road, east of the mill. Water was supplied by artesian wells and stored in a massive tank. A steam-powered pump fed the water to the city. A good water system attracted affluent residents to Birmingham.

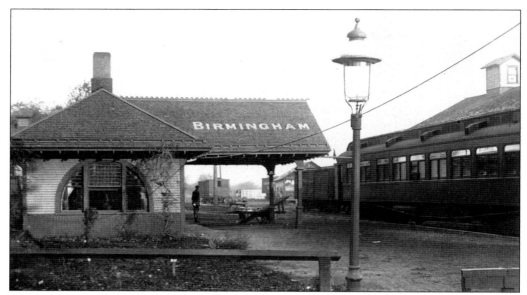

The old train depot on Woodward Avenue was an exciting place for kids. Edward Smith (1898–1998) recalled visiting the depot as a child: "The farmers would bring the milk in the morning to ship to Detroit . . . most of the bread that was sold in Birmingham at that time came on the morning train." Smith learned the alphabet reading the letters on the sides of the railcars.

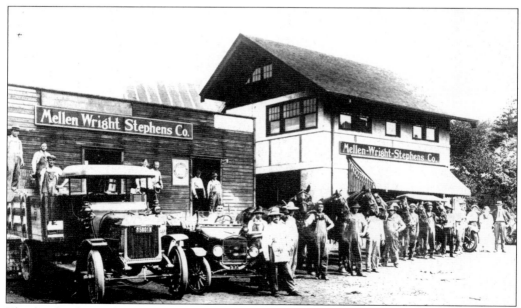

The first lumber and coal business in Birmingham was located on the east side of the Chicago and Grand Trunk Railway tracks that ran along the current path of Woodward Avenue (Hunter). The lumberyard was originally operated by Ira Slade, who became village president in 1889. This photograph was taken about 1915. Alban's Bottle and Basket restaurant occupied this location for years.

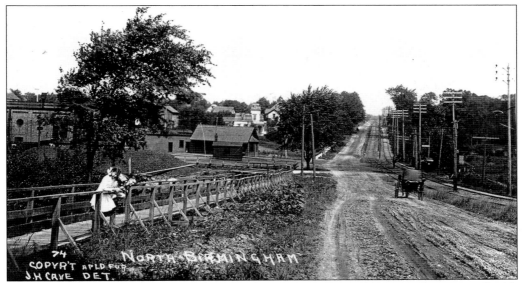

A lone buggy travels north up Old Woodward Avenue in about 1912, past what is now Booth Park. The interurban tracks are on the east side of the road. Dena Hallock Tyson (left) grew up on Ann Street. In 1979, she wistfully recalled taking the DUR to Pine Lake and downtown Detroit to catch the Bob-Lo boat. Her family got its first Ford Model T in 1915.

After Birmingham got its water system in the 1890s, the Village Improvement Society started looking for ways to spruce up the town. The Umbrella Fountain was placed at the southeast corner of Maple Road and Old Woodward Avenue. The fountain disappeared for about 60 years. It was recently discovered in a barn on Southfield Road near Maple Road, but in poor condition. The man in the photograph is barber Guy Taylor.

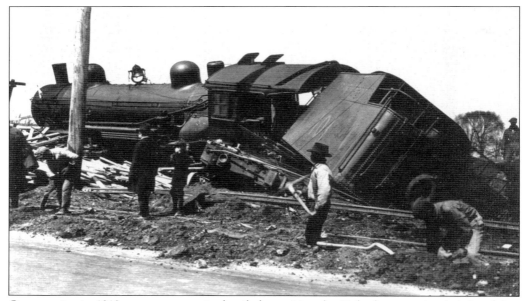

One evening in 1910, a passenger train derailed near Lincoln. Nobody was seriously injured, but the conductor needed to warn other engineers about the disabled train. The local station agent was unavailable, so Ned Daines broke a window at the depot and used his Morse code training to contact the dispatcher. A catastrophe was averted, and Daines was not asked to rely on his other training—as an undertaker.

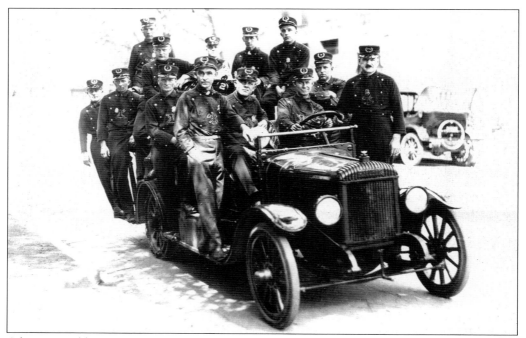

A harrowing blaze at the National Hotel in 1913 made villagers aware that they needed more fire protection. In 1915, the department bought its first motorized fire truck, nicknamed the "June Bug" because, according to Merritt Olsen, "It bounced and danced around like a June Bug."

Martha Baldwin Park, at the intersection of Maple Road and Southfield Road, was once a gravel pit owned by the Baldwin family. In 1899, Martha Baldwin gave the land to the village under the condition that it must always be used as a park. The pleasant green space was almost lost when the Ring Road bypass was planned in the 1960s, but deed restrictions prevented it.

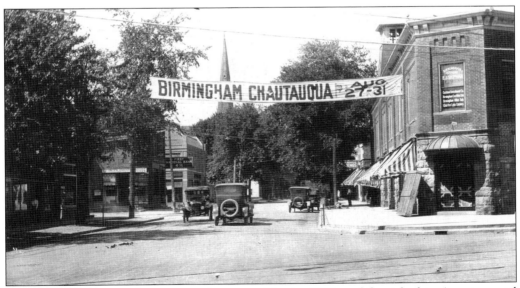

Chautauqua was a social movement that started in the 1870s and flourished in America until the mid-1920s. Chautauquas included lectures, dance, music, drama, and other forms of "cultural enrichment." Birmingham's Chautauqua was held on the grounds of Hill School. Lectures and educational programs for children were held under a huge tent in the daytime; activities for adults were scheduled at night.

Electric Park was created in 1900 in a former grove on the east side of Old Woodward Avenue across from today's Booth Park. Eight years before electric lights came to the village, the park had lights provided by the DUR powerhouse. Moms and dads from the entire Detroit area rode the trolley for picnics and games at the illuminated park. All towns in the early 1900s had a "lovers lane" where young couples could get away from their parents, such as this one along Maple Road in Martha Baldwin Park.

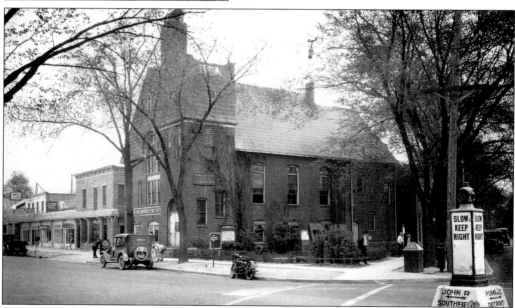

When the town outgrew its first library in the Methodist church, Martha Baldwin led the purchase of the land at the southeast corner of Maple Road and Old Woodward Avenue. A fund-raising drive fizzled, but Baldwin convinced the city fathers to build this two-story building in 1895 that also housed the fire department, police department, and village offices. It became known as Library Hall.

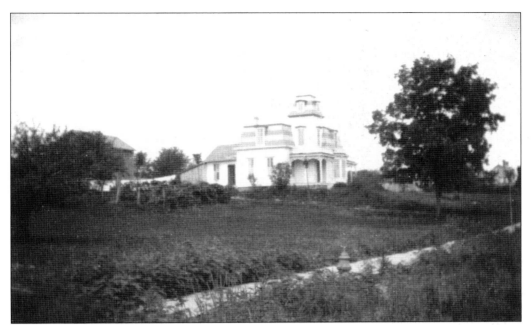

Schoolteacher and young widow Emma Chatfield Robinson (1856–1938) raised three children in this Second Empire Victorian on the west side of Old Woodward Avenue north of Harmon Street. Robinson's parents were early Troy settlers who moved to Birmingham in about 1875. Robinson grew up in the house on Maple Road next door to Martha Baldwin's house. Robinson's granddaughter Shirley Hersey lived in the Maple Road house until she died in 2007 at age 87.

In the days before refrigeration, Quarton Lake was Birmingham's source of ice. Large blocks were packed in sawdust and stored in the barn shown here at the south end of the lake. The ice-cutting operation was owned by William Olsen until 1916, when Quarton Lake Estates was planned. A modern ice plant was later built just south of Maple Road, between Elm and Worth Streets.

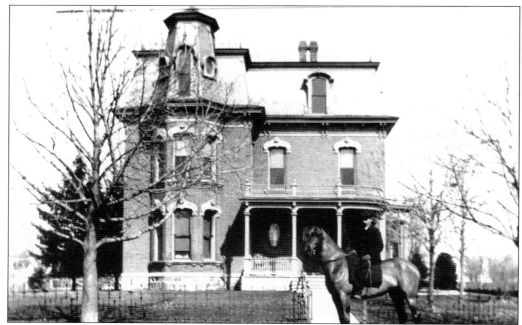

The distinctive Victorian house at the corner of Old Woodward Avenue and Brown Street is usually referred to as the Ford-Peabody Mansion. It was built by Frank Ford and later occupied by his daughter Alta and her husband, J. Bert Peabody. The photograph above was taken around 1900.

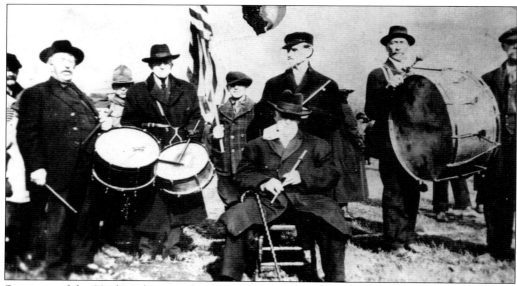

Survivors of the 22nd Michigan Volunteer Infantry gathered at the United Presbyterian Church for a reunion on August 31, 1901. At the Battle of Chickamauga in 1863, the 22nd Michigan Volunteer Infantry was abandoned on the battlefield as the rest of the Federal army made its retreat. Some managed to hide or play dead, but most were captured and sent to Andersonville Prison in Georgia.

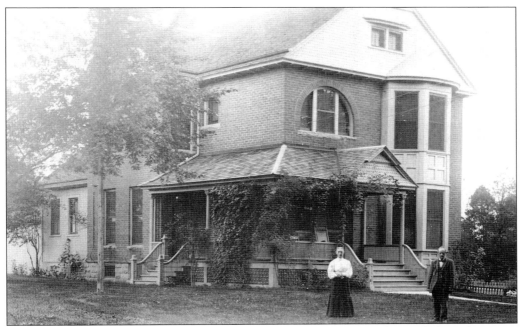

William and Rachel (Hagerman) Smith lived on the north side of Maple Road, three doors east of the Grand Trunk Depot. The location is about where the Kroger store is today. The house was built by William's son, Edward R. Smith Sr., who operated a lumber and coal yard. This photograph was taken in about 1905.

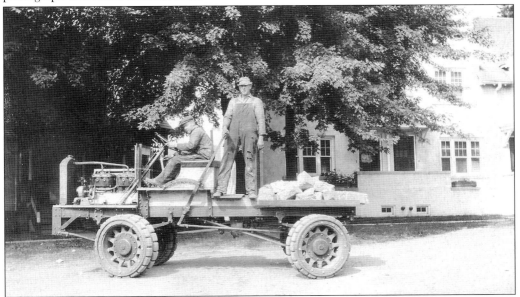

The Weier-Smith Truck Company was Birmingham's lone entry into the automotive business. In the early 1900s, the company manufactured one of the country's first four-wheel-drive vehicles in a machine shop on the east side of Brownell Street (now Peabody), just south of Maple Road. The trucks were well suited to the muddy roads of the day. The Birmingham Eccentric used this W-S truck for delivering newspapers.

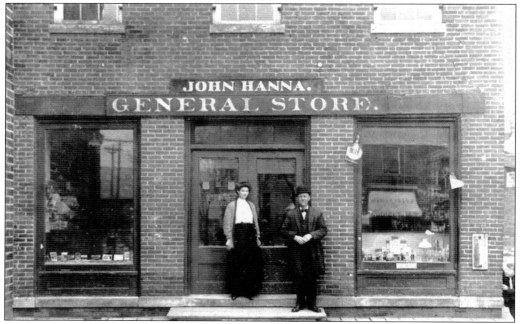

Burglars in the early days found safes an irresistible target. One morning in 1909, John Hanna found the double door to his store's safe blown wide open. The burglars only got $5 worth of change because they did not notice a chest that held the money. Neighbor Irving Bailey heard the explosion in the night: "Somebody's safe is blowed up," he calmly said to his wife, and went back to sleep.

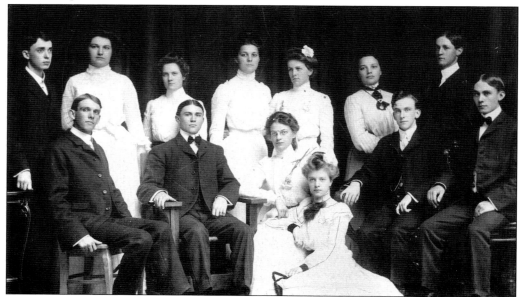

In 1902, the University of Michigan and Stanford played in the first Rose Bowl, Pres. Theodore Roosevelt advocated the purchase of the Panama Canal, and the 13 young people above graduated from Birmingham High School. Some of the names of the graduates live on: George Purdy and Knox Poppleton were members of the 1902 class.

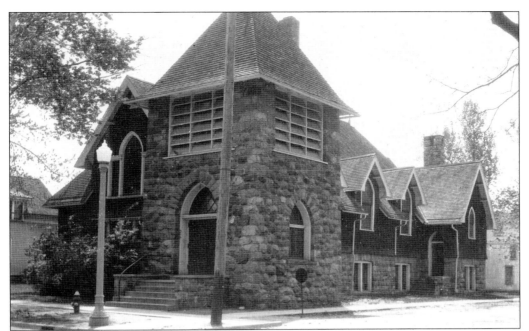

In 1919, the *Birmingham Eccentric* reported, "We have eight church denominations in prosperous condition. If you can't get to heaven via Birmingham, why try elsewhere?" At that time, the St. James Episcopal Church on West Maple Road was firmly established. Episcopal church services were first conducted at Library Hall in 1894. A permanent church was completed in 1895 at a cost of $5,000.

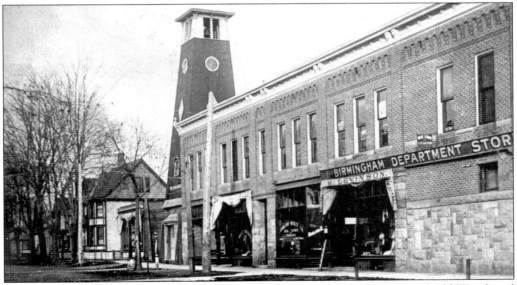

Levinson's Department Store occupied the northwest corner of Maple Road and Old Woodward Avenue between 1897 and 1916. The First State Savings Bank and Wilson Drugs followed Levinson's Department Store in that location. The hose tower can be seen in the background. Built in 1892, the tower was used to dry the town's 500-foot fire hose. An alarm bell at the top called the village's volunteer firefighters to action.

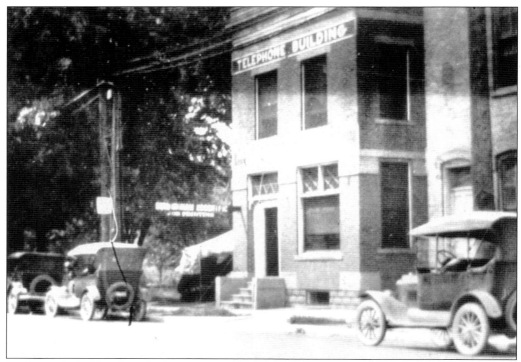

In the early 1900s, the telephone company was located in this building at 148 Pierce Street across the alley from Whitehead and Mitchell's Drugstore. Edward Smith says his father must have been the first subscriber because his telephone number for many years was simply "1." The switchboard only operated in the daytime and just for a few hours on Sundays.

Alice Hagerman Thurber (1871–1952) was an accomplished painter who sold 300 pieces in her lifetime. She was born in her grandfather John Daine's National Hotel. She studied piano at Oberlin College, was a member of many professional organizations, and was the organist at St. James Episcopal Church. She grew up on Old Woodward Avenue, just north of Willits Road. Here she works on a painting alongside the Rouge in Electric Park.

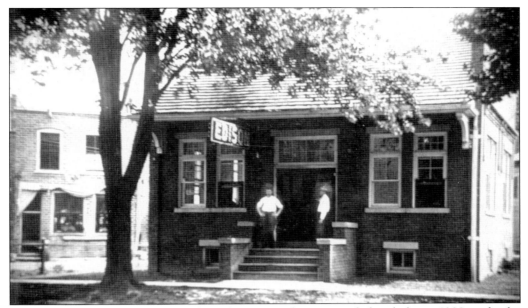

The St. Clair Edison Company brought Birmingham out of the dark in 1908 with the introduction of current and lamps to the village trustees' room, the jail, the public library, the waterworks, and the fire station's hose house. In 1910, Birmingham got its first lighted street. This advancement attracted many new residents to town. The Edison Company's substation at 147 Pierce Street was later turned into a two-story building. It still stands today.

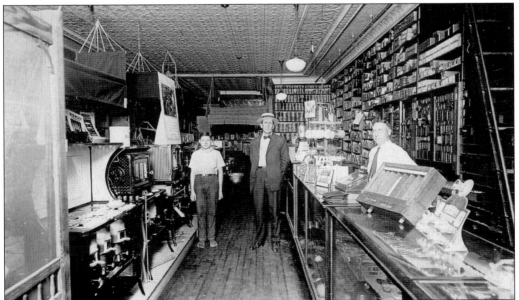

Elmer Huston takes a break from his duties behind the Huston Hardware counter to pose for this photograph. With him are clerk Paul Kurth, 14, and George Wells, a salesman from Buhl and Sons Wholesale Hardware in Detroit. Kurth bought the store on North Old Woodward Avenue from Huston in 1940 and operated it until 1987. Hugh Irving's ramshackle hardware store previously occupied the site.

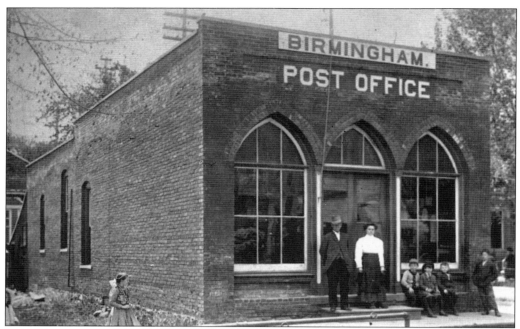

In 1907, postmaster John Hanna was piqued about how patrons were using post office pens. He issued these sarcastic rules: "Dip the pens very deep in the ink well; then, jab pen in the desk three times. Pick teeth with pen while meditating what to write. Then proceed to write and kick about the poor pens and ink provided by the post office." Hanna sure was a funny guy.

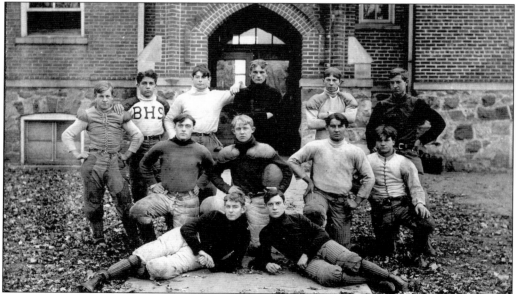

The 1906 Birmingham High School football team gathered in front of Hill School for this photograph. The uniforms were mismatched because each player supplied his own equipment. The team beat Pontiac and Royal Oak before closing out the season with a 78-0 thrashing of Wyandotte. Birmingham was a tough team. One time, several Pontiac players were hurt so badly they had to be carried to the DUR in a wagon.

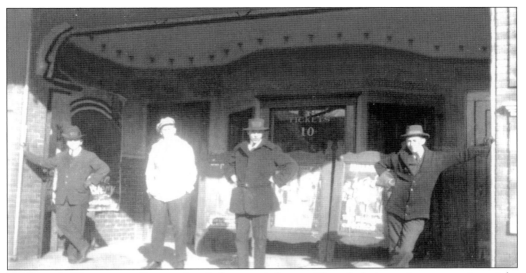

The Family Theatre was Birmingham's first movie house. The admission price on opening night in 1913 was 10¢. Appropriately the theater was on Old Woodward Avenue, where the Uptown Palladium building is now. The primitive photograph above shows John Schram, theater manager, far left, and Edward R. Smith Jr., projectionist, far right. The photograph was taken with an inexpensive Kodak Box camera, popular among children in the early 1900s.

Even into the 1900s, much of Birmingham was farmland or wooded. This photograph shows the wilderness that was Pilgrim Road prior to the development of Quarton Lake Estates. In the 20th century, Birmingham grew geographically as land was annexed from Bloomfield Township. This area west of Quarton Lake was annexed to become part of Birmingham in 1922.

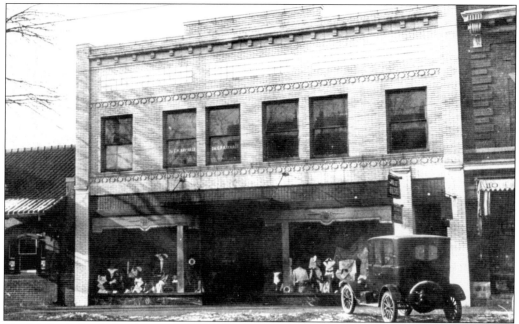

The McBride family has been in the hardware business in Birmingham for many years. Between 1915 and 1920, the family constructed the McBride Building on South Old Woodward Avenue. Russ McBride sold out to the Couzens family, so he had to change the name of the business to Russell Hardware, a name that survives to this day.

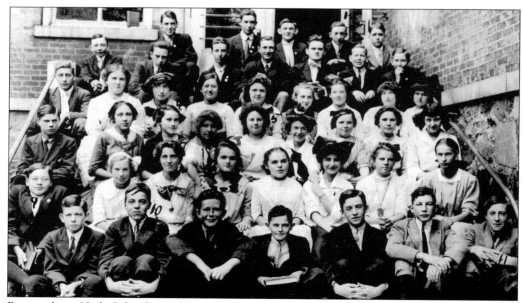

Birmingham High School's students about 1912 included Bessie Levinson, in the second row, third from the right. Her father, Morris, owned Levinson's Department Store. After college, she moved to the Boston Boulevard area of Detroit. Her children include Sen. Carl Levin and Congressman Sander Levin.

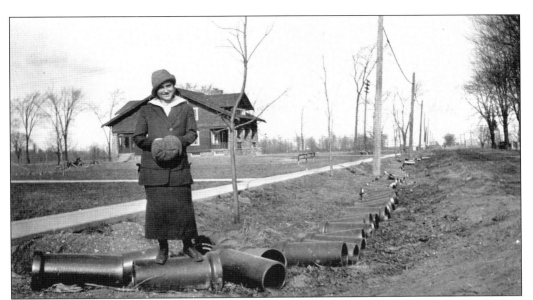

Maple Road was a dirt road until about 1916, when it was paved between Adams and Southfield Roads. Old Woodward Avenue was paved at the same time. In the photograph above, Derua Davenport stands near the corner of Worth Street and Maple Road. The house in the background sits at the northwest corner of Maple and Adams Roads. It was built in 1914 by Davenport's father, William Davenport.

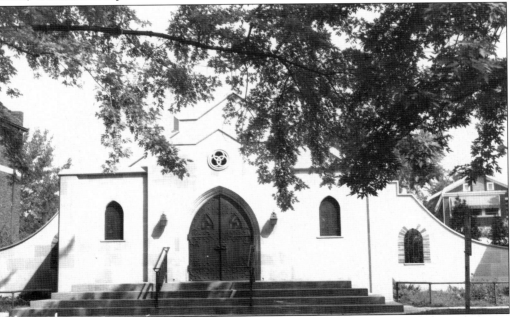

On May 12, 1918, a small group of Roman Catholics assembled in the second floor of the Johnston-Shaw Building and made plans for a new church. A lot at the corner of Harmon Street and Woodland was designated for what would become Holy Name Parish. The plans called for a church, school, convent, and rectory. The distinctive Spanish-style church was dedicated on April 30, 1922. It was replaced with a larger church in 1955.

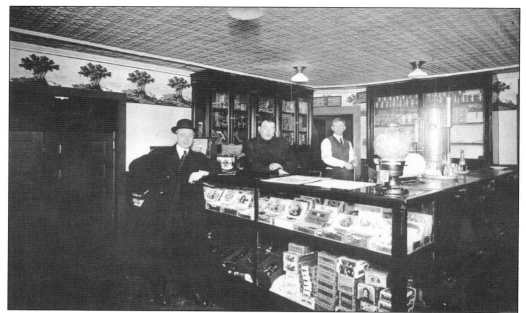

Cigar salesman Joe Marswell stands at the counter of Fred and Will Hopson's cigar store and poolroom in this 1915 photograph. The Hopsons operated the business in the Birmingham Inn, which had previously been the National Hotel but was rechristened and rebuilt under the proprietorship of James Wooster in 1910. Over Marswell's shoulder are the swinging doors that led to the bar, which had six pool tables.

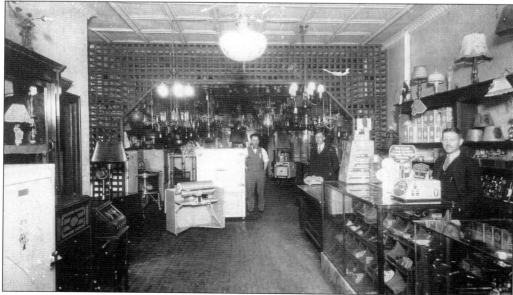

Leonard Electrical Company proprietor Homer Leonard was Birmingham's own Thomas Edison. In the 1900s, people on rural routes often flagged down the DUR at night with lit newspapers. Leonard wired an ingenious light for Morris Wattles so he could signal the train to stop at the Wattles Farm to pick him up for school. In Leonard's store above are, from left to right, Carl Ely, Leonard, and Russ Fisher.

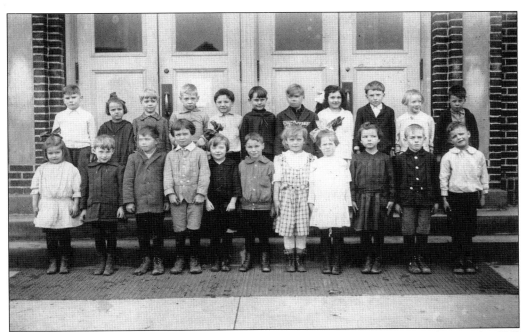

Barnum School opened in 1912 as an elementary school to relieve overcrowding at the Hill School. It was named for Horace Barnum. He owned the acreage the school is located on and was a town blacksmith and a village trustee in the 1870s. The original building was called "the tower" because of its narrow, high windows.

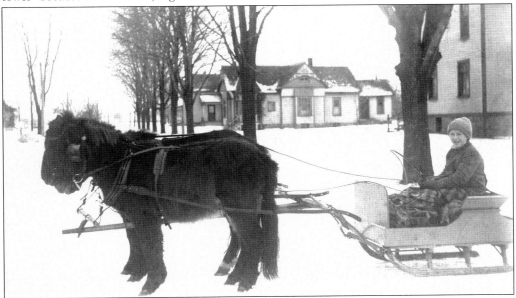

In the photograph above taken in the winter of 1909–1910, two ponies named Captain and Colonel take Edward R. Smith Jr. for a trip across town. It is likely that the ponies were from the Watkins Pony Farm. Watkins loaned the ponies out during the winter to people who promised to take good care of them. Captain was later sold and awarded as the prize for a subscription contest for paperboys held by the Detroit News.

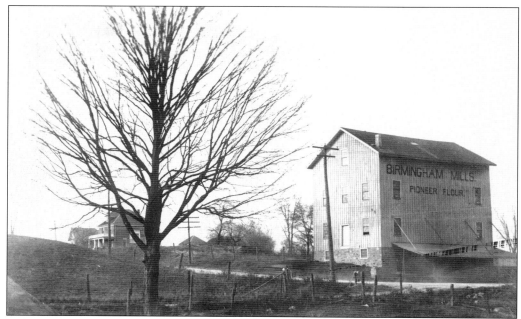

Birmingham's mill was the cornerstone of commerce throughout the 1800s. But as the farms disappeared around it, there was no longer the need for a mill. In 1918, owner Niles Hansen sold the old mill and property to make way for Quarton Lake Estates. That same year, a new dam was built and the millpond was rechristened Quarton Lake.

This compact house on Hamilton Row was built in 1916 by Edward R. Smith Sr. After selling his nearby lumber business, Smith realized he had a barn full of unused lumber. He hired a carpenter to use the scraps to build a two-story house with a stucco exterior. It was the last house remaining on Hamilton Row when it was torn down recently to make way for an office building and condominiums.

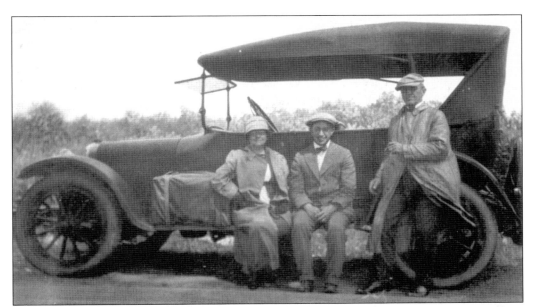

In simpler times, families often took a Sunday drive. In this photograph taken about 1920, (from left to right) Cora Eliza Bailey Horton, Max Horton Sr, and Henry Wilbur Horton take a break at the side of the road. Max's wife, Bertha, probably snapped the picture. The photograph was taken somewhere in the vicinity of Big Beaver Road and Woodward Avenue.

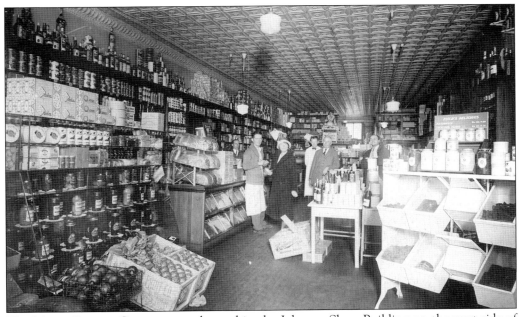

The Miner Grocery Company was located in the Johnson-Shaw Building on the west side of Old Woodward Avenue. Miner's slogan was "The home of good things to eat kept well." An advertisement for the store in a 1916 issue of the *Birmingham Eccentric* said, "The protracted dry weather means high prices, scant supply and inferior quality of vegetables. Anticipate your wants—save money and get better values."

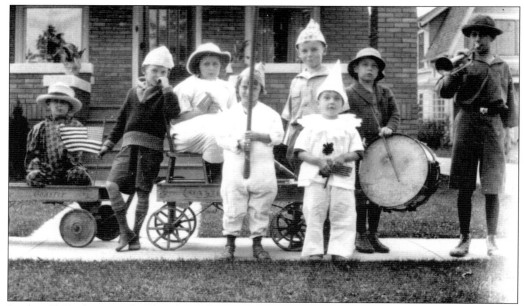

In this 1922 photograph taken by Orlou Bayley, a group of happy kids pose in front of a house on Oakland Avenue. Whether these kids were putting on their own parade or marching in the village's Fourth of July celebration is anyone's guess. The house was torn down when Oakland Avenue was widened to become a boulevard.

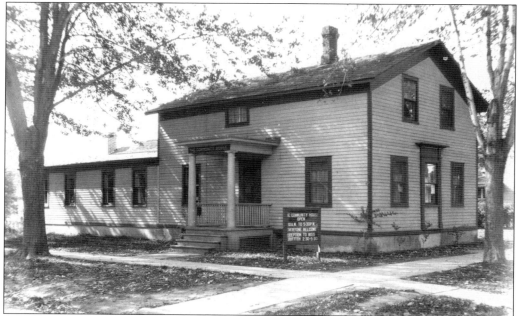

A forward-looking rector of St. James Episcopal Church named Rev. Charles Harden McCurdy pioneered the idea of building a community house for Birmingham. In 1920, a series of meetings was held to explore the idea, and the St. James Women's Guild began developing policies and plans. In 1923, the Community House was founded in a rickety frame house at the corner of Maple Road and Bates Street.

Four

THE BOOM AND
THE BUST

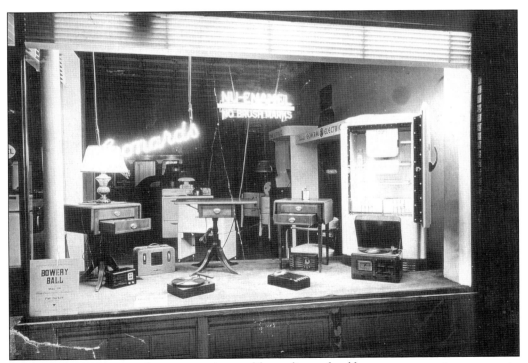

In the 1920s, many modern conveniences like radio and self-serve grocery stores came to Birmingham. Leonard Electric Company and the A&P were two of the early businesses in the Leonard Building on West Maple Road. The building was constructed in 1924. Kay Baum's women's clothing store occupied it from 1955 to 1983, after many years on the south side of Maple Road just west of Old Woodward Avenue. Leonard Electric Company's window display is shown here.

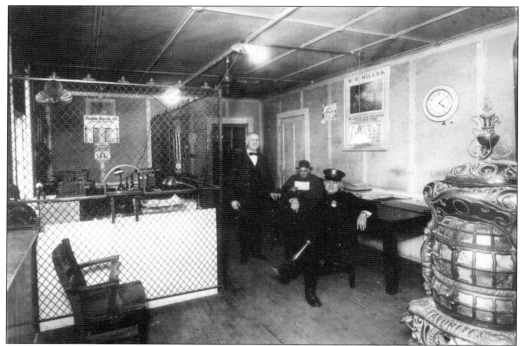

An old-fashioned coal stove heated the village treasurer's office at Library Hall on this icy day, January 11, 1922. Village treasurer John Hanna (left) and police chief Homer Gaskill (seated, front) appear to be waiting for property owners to bring in their annual tax payments.

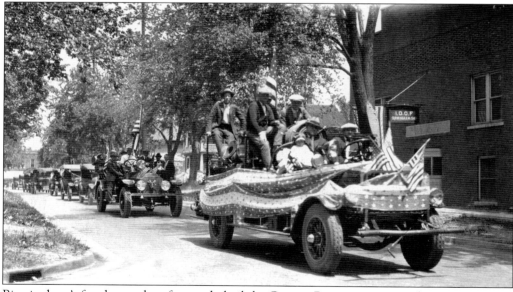

Birmingham's first heavy-duty fire truck, built by Gramm-Bernstein, crosses the intersection of Pierce and Merrill Streets during the Fourth of July parade in this 1924 photograph. The truck behind it is the American LaFrance pumper that the city bought after the eye-opening Field Building fire in 1923. Bill Olsen now owns the American LaFrance truck, which tours the town once each year in the Michigan Week Parade.

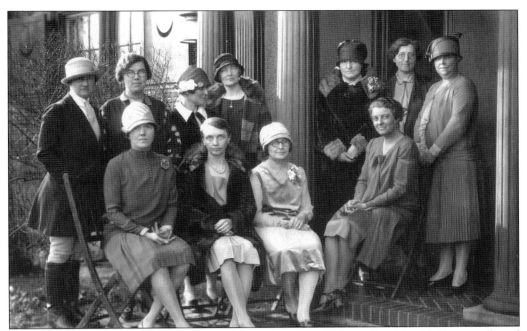

The Executive Board and Planning Committee of the Birmingham Community House gathered for this photograph sometime in the 1920s. Seen here are, from left to right, (first row, seated) Mrs. Milton R. Schaatz, Mrs. J. H. Marlotte, Mrs. J. F. Donnelly, and Mrs. J. R. Donovan; (second row, standing) Mrs. Howard L. Simpson, Mrs. Charles J. Shain, Mrs. Harvey Whelan, Mary Griffith, Mrs. R. C. Disereust, Mrs. Seymour D. Adams, and Mrs. R. H. Mayor.

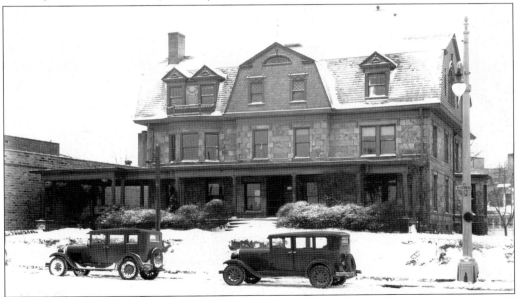

The Chateau Tea Room was located at the southwest corner of Willits Road and Old Woodward Avenue. It was built in 1898 of Ionia sandstone and was among the most elegant residences in Birmingham. H. Wales Price ran the restaurant. His family lived upstairs. Price survived World War I without a scratch but lost his leg when he crashed a Jenny biplane in Toledo in 1919.

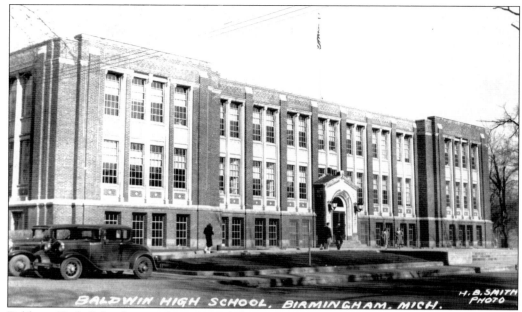

Baldwin High School opened in 1918, replacing the old Hill School. It was financed in part with the proceeds from Martha Baldwin's estate. The school's most innovative feature was the first elevated running track in the state. Through the 1930s, nearby school districts had their own elementary schools but their students paid tuition to attend Baldwin High School. Baldwin High School was demolished in 1974.

Harry and Marion Allen built the Allen House in 1928 on the site of the redbrick school. The property was originally owned by pioneer Elijah Willits, who sold it to the Fractional School District. Harry was the first mayor of the City of Birmingham when it was incorporated in 1933. The Allen House is now part of the Birmingham Historical Museum and Park.

Charles Shain served as village president from 1924 to 1926. When the state wanted a bypass around downtown, Shain placed a water tower in the middle of the right-of-way near today's Kroger grocery store to thwart the effort and maintain traffic in town to help the merchants. Shain lived on the east side of Pierce Street north of George Street. A horseman, he enjoyed riding a sleigh pulled by two horses into town.

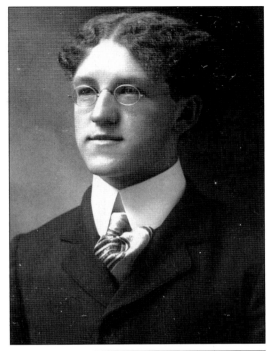

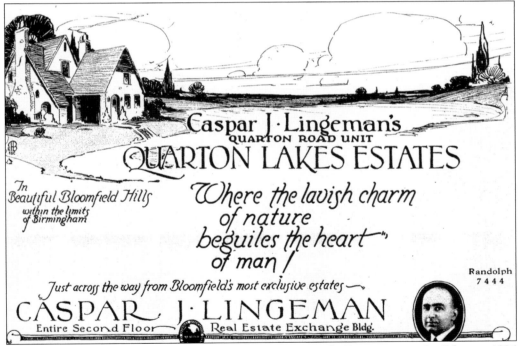

Caspar J. Lingeman's
QUARTON ROAD UNIT
QUARTON LAKES ESTATES

In Beautiful Bloomfield Hills within the limits of Birmingham

"Where the lavish charm of nature beguiles the heart of man!"

Randolph 7444

Just across the way from Bloomfield's most exclusive estates—

CASPAR J. LINGEMAN
Entire Second Floor Real Estate Exchange Bldg.

This advertisement touting the benefits of life in Quarton Lake Estates ran in the February 1926 issue of *Afterglow*, a magazine devoted to "news and comment of country life around Detroit." *Afterglow* ran photo stories in the same issue about Charles C. L'hommedieu's New England farmhouse on Dorchester Road and Wallace Frost's house on Tooting Lane.

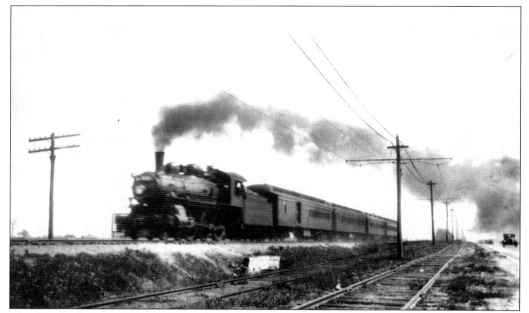

The 10-wheel Grand Trunk Steam locomotive shown in this 1928 photograph is highballing north along Woodward Avenue. The DUR tracks are alongside it. The automobile in the right side of the photograph seems to confirm that the likely location of the photograph is between the city of Royal Oak and Lincoln where the tracks veered away from Woodward Avenue.

The neighborhood in the vicinity of Old Woodward and Oakland Avenues in the 1920s was comprised mostly of new homes. Many middle-income residents lived on streets such as Park, Ravine, and Ferndale. In the photograph above, the camera is looking east along Oakland Avenue toward what is now Woodward Avenue.

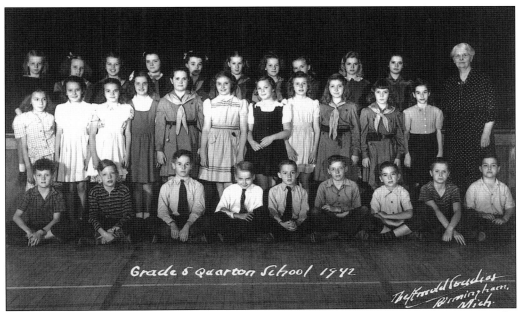

Grade 5 Quarton School 1942

Quarton School was built in 1927 to serve kids in the new Quarton Lake Estates area. The school was named for Fred V. Quarton, son of Birmingham homesteaders and a village trustee. Construction of the school cost $313,000 and was paid for through a bond initiative. The photograph above shows Mrs. Waterman's 1942 fifth-grade class. Student Betsy Kausch remembers her as being very strict.

Violet Gross lived at 608 Floyd Street and graduated from Baldwin High School in 1925. Her scrapbook provides many memories of her days at Baldwin High School, including the program from the musical *Once in a Blue Moon*, which was presented in May 1924. The cast included Muriel Johnstone, Orlou Bayley, Winifred Huntoon, Kathleen Miller, and Rollin Smith. The accompanist was Mildred Green.

ONCE IN A BLUE MOON

A Musical Romance

Presented By

THE BOYS' AND GIRLS' GLEE CLUBS

MUSIC DIRECTED BY
MISS MYRA E. GRATTAN

DIALOGUE DIRECTED BY
MRS. M. C. HART
MISS KAYE PEACOCK

DANCE DIRECTED BY
MISS JEANETTE KRIEKARD

BALDWIN AUDITORIUM

Friday evening, May 9, 1924, 8 o'clock

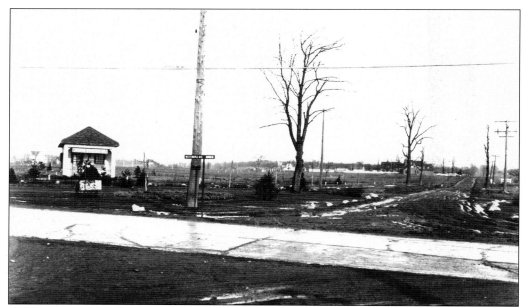

Birmingham's population and the area's reputation as a premier residential community both took off in the 1920s. The photograph above shows the corner of Maple and Cranbrook Roads around 1920. The thimblelike building on the northwest corner was the sales office for developer Judson Bradway's Bloomfield Village, which is just beyond Birmingham's western limit. The Hupp family once had a pig farm where Bloomfield Village is today.

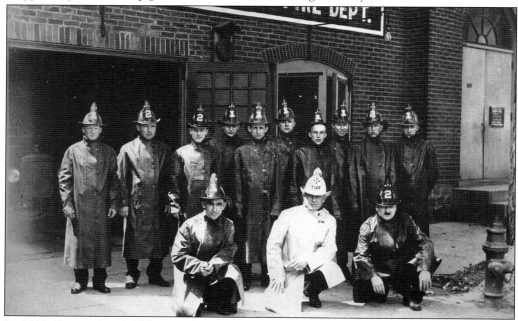

In 1926, Birmingham's Volunteer Fire Department posed for this photograph in front of the station located in Library Hall. The department had 20 men led by Chief William G. Olsen, kneeling, second from left, and his assistant Glen Allen, appropriately standing directly behind Olsen. The department responded to about 85 calls in 1925.

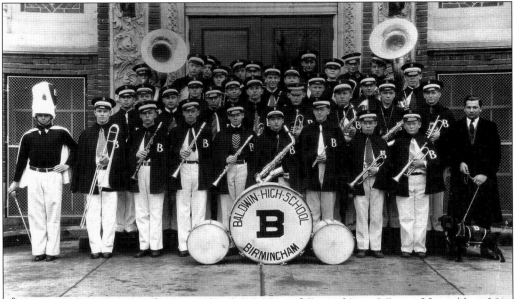

Left to right. Front Row- T. Martindale (drum-major), E. Deer, S. White (manager), D. Stewart, L. Robinson, E. Shumway, D. Burgess, J. Coons, S. Bell, A.W. Berndt (director) and Bozo (mascot); 2nd row- J. Thatcher, G. Schwallie, J. Blakley, J. Shepherd, J. Pratt, G. Anderson, D. Mills (librarian), R. Gillespie (student director); 3rd row- R. Grommesman, J. Russell, H. Pearson, T. Gail, H. Eggert, J. Wenzl, D. Parry; 4th row- W. Jensen, W. McDonald, H. Clark, K. Jones, C. Streb, R. Filkins, G. Laughlin; 5th row- R. Gibbons, G. Flower, R. Brown, F. Stolberg; absent from Picture- C. Lawer.

In 1927, the Birmingham School District created a music program in the schools. The band's first director was Arnold Berndt. In a 1957 interview, Berndt told *Birmingham Eccentric* that there were a total of 16 students in the first band. The 1930 Baldwin High School band is shown here.

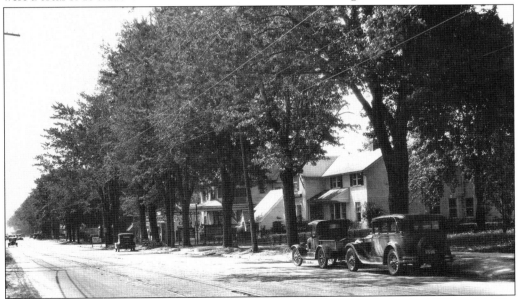

Transportation has always played a major role in Birmingham's growth. In the 1870s and 1880s, aging pioneer farmers moved to Birmingham for the conveniences of living in a village. In 1900, the interurban attracted residents who commuted to office jobs in Detroit and lived within walking distance of the tracks. In the 1920s, better roads attracted automotive executives who commuted to jobs with automotive companies in Detroit and Pontiac.

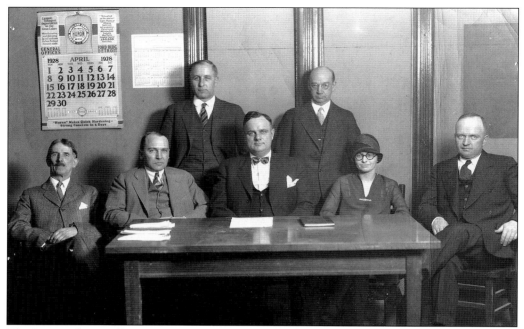

The Birmingham Village Trustees are all business in this photograph taken in April 1928. Seen here are, from left to right, (first row) W. W. Henry, Lee A. White, village president H. T. Ellerby, Hope F. Halgren, and Scott Hersey; (second row) H. J. McBride and Lawrence Hulbert. Halgren was an entrepreneur who later founded the Dy-Dee Wash laundry service.

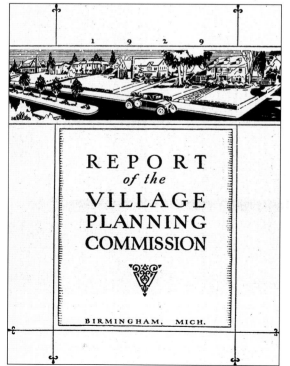

The village was ahead of its time when it commissioned a planning report in 1929. The report began, "Birmingham is an integral part of the Detroit-Pontiac region. It is also more or less a self-contained residential community. Neither of these aspects can be slighted: their harmonizing presents the greatest problem of the plan of the village." Many of the plan's recommendations for street design, zoning, and parks are intact today.

Charles Shain led the effort to purchase property for the municipal building, Baldwin Public Library, and Civic Center Park, which was later named in his honor. Houses on all three parcels were demolished or moved prior to construction. The southwest corner of Martin Street and Henrietta is shown in this photograph. Shain's initial plan called for a civic center strip that stretched all the way from Pierce Street to Southfield Road.

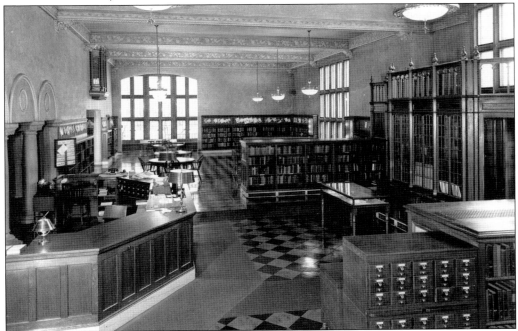

The construction of Baldwin Public Library and the Birmingham Municipal Building (city hall) was funded by a voter-approved bond issue in 1926. Work on the library was completed in 1927 at a cost of $175,000. Substantial additions were built in the 1960s and the 1980s. The residents of Birmingham have a strong tradition of supporting the community and its schools with their pocketbooks.

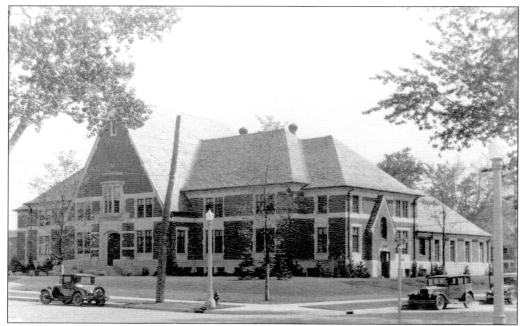

The Birmingham Municipal Building was completed in 1928 and originally housed the village and township offices, as well as the fire and police departments. The tower was used for drying fire hoses until about 1950. The Birmingham Municipal Building and library were designed by the local firm of Burrowes and Eurich.

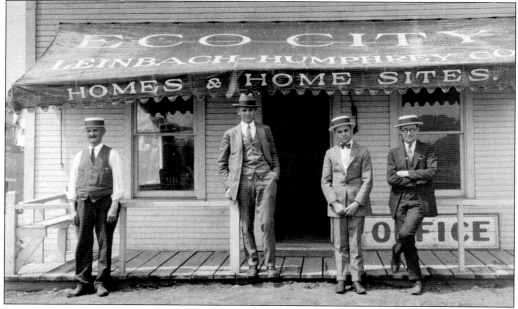

During the boom period of the 1920s, housing of all types and prices was in demand. Eco City (as in economical) offered affordable kit houses. Over 700 homes were built on streets south of Lincoln and north of 14 Mile Road. Eco City's sales office was at the northwest corner of Davis and Woodward Avenue. After it was developed, Eco City became known as the tough part of town.

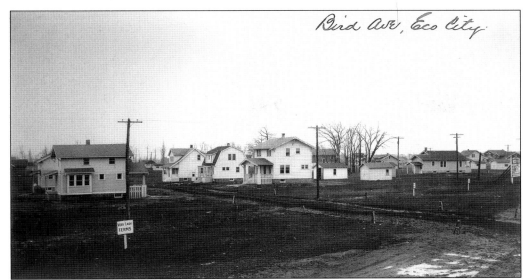

In the early 1920s, only a few houses had been built in Eco City, and the roads were nothing more than muddy tracks. Bird Avenue is shown above, taken from Woodward Avenue. The photograph was provided by Ellie Sullivan, whose father, Theodore Schnabel, sold houses for the Leinbach Humphrey development company. Eco City had its own water tank but no sewer system. Some of the houses even used privies.

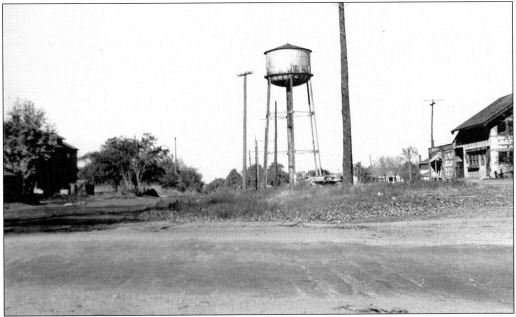

In the 1930s, the State of Michigan pressed hard for a bypass around Birmingham to ease congestion on then Woodward Avenue. The state relocated Grand Trunk's railroad tracks east of town. The state also paid to move Birmingham's water tank from its location near present-day Kroger's to Eton, near Lincoln. The photograph above (looking north) shows the intersection of Maple Road and Woodward Avenue before the bypass was built.

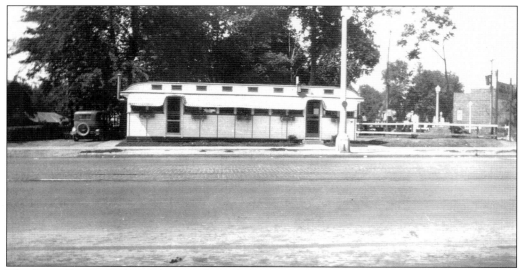

The Dixie Diner was located across from the Birmingham Theatre on Old Woodward Avenue in the late 1920s. Bud Stinson was often behind the counter. In the photograph above, the Oddfellows Hall (now the Varsity Shop) can be seen at the far right. In the 1930s the Dixie was moved to the north side of Merrill Street just west of Old Woodward Avenue where the Merrillwood Building is today. (Hanover History Center.)

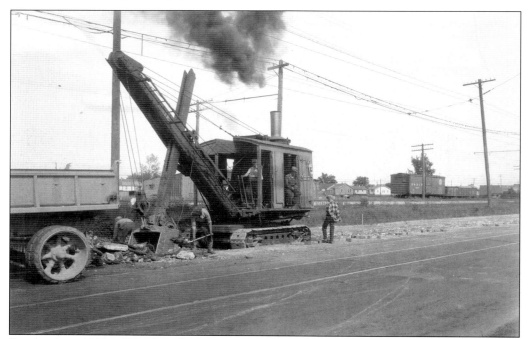

By the late 1920s, Woodward Avenue was so congested on weekends that locals made a spectator sport of watching all the cars creep through town. Many residents fought the widening of Old Woodward Avenue because they did not want to lose the canopy of elm trees that lined the road. The citizens of Birmingham have won many battles over the years, but this time, the residents—and the trees—lost.

Many of the houses in Quarton Lake Estates were built in the 1920s. Most cost between $3,000 and $6,000. Deed restrictions ensured that "no cattle, horses or other farm animals shall be kept on any lot. A reasonable amount of poultry and dogs for the private use of the owner may be kept when properly confined." This house is on Pilgrim Road.

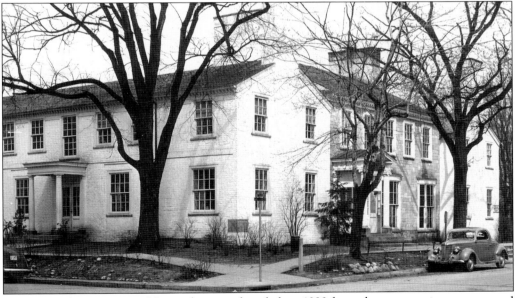

The original Community House that was founded in 1923 hosted many parties, events, and civic meetings. The Community House board soon realized it needed new and larger facilities. Community House president Ruth Shain spearheaded a fund-raising campaign in 1928 to build a new Community House, which opened in 1930 at the southwest corner of Bates and Merrill Streets.

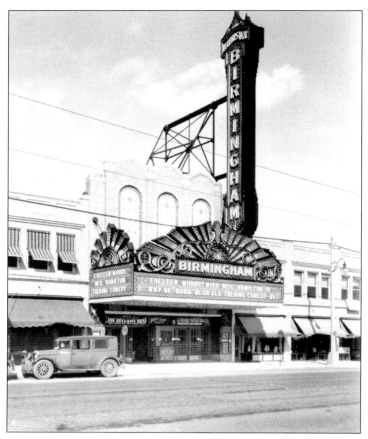

In 1928, the Kunsky neighborhood theater chain opened the Birmingham Theatre. Presentations included vaudeville productions and silent films, such as *The Gold Rush*, starring Charlie Chaplin. A mighty organ to the right of the stage played throughout the picture. The photograph at left shows the exterior in March 1928. Old Woodward Avenue had just been widened, resulting in the loss of hundreds of elm trees. The photograph below shows the grandeur of the Birmingham Theatre as it was.

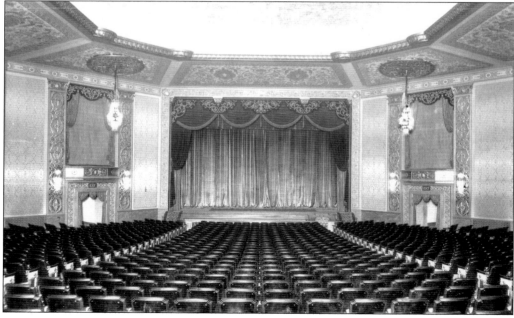

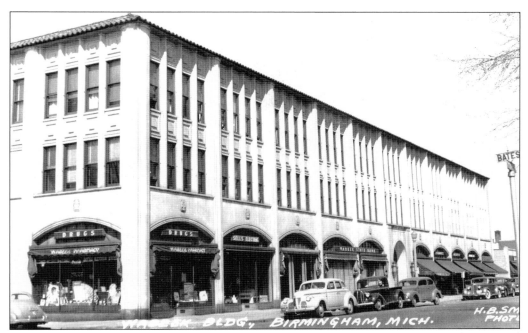

Plans for the Wabeek Building were drawn by leading architect Albert Kahn. The original design called for a building eight stories tall with a footprint that would accommodate more than 20 stores on the main floor. Residents objected to the height of the building and successfully got the plan scaled back. It was not the last time that building height was to become an issue in Birmingham.

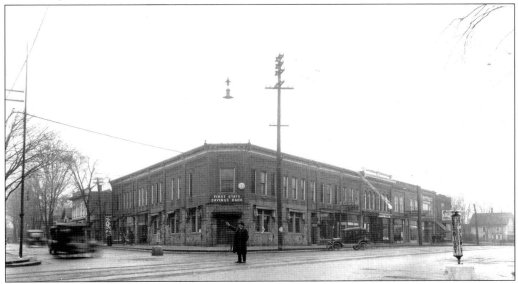

The Great Depression began with the stock market crash in October 1929 and caused upheaval in Birmingham until World War II. Among the casualties was the First State Savings Bank, which closed in 1931 and deprived customers of their assets. One-time mayor Milton F. Mallender complained years later that he had just gotten back from a fishing trip and only had $5 when the bank closed.

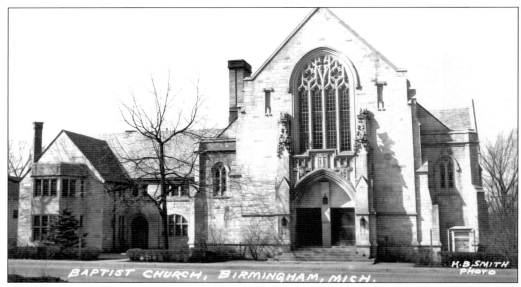

The First Baptist Church was completed in 1929. Seven months later, the stock market crashed, and the congregation struggled to pay its bills. Fortunately bank creditors had their hands full with other matters and allowed the congregation to remain in the building as long as they maintained it properly. The debt was paid 20 years later. The Baptists have occupied the site on Willits Road since 1873.

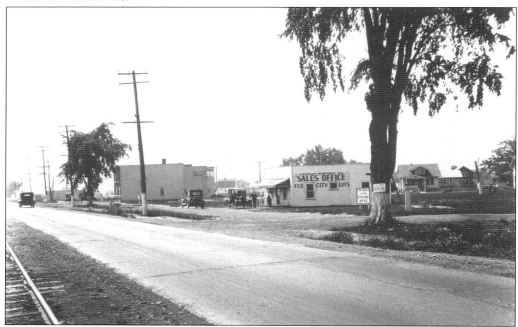

In 1931, Michigan's unemployment rate was 18 percent. By 1933, it was 46 percent. Some shops closed, and the increase in population slowed, but Birmingham persevered. Don Upward, who grew up on Purdy Street in the 1920s, remembers lots of "leftovers and hand-me-downs." One concession to the depressed economy was that the Birmingham City Commission allowed residents to pay their property taxes in installments.

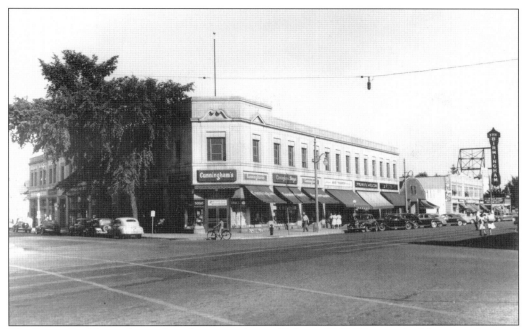

The Briggs Building is located on the original site of Library Hall. The new building was designed by C. Howard Crane, who also designed Detroit's Fox Theater. Work began in 1929. Construction of the building cost $200,000, and original tenants included the Birmingham Department Store, F. W. Woolworth, and the Piggly-Wiggly, which was Birmingham's first self-serve grocery store and certainly has the best name of any business to ever operate in Birmingham.

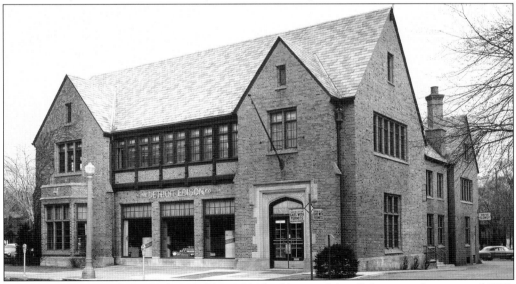

Detroit Edison moved into its dignified $100,000 building on Merrill Street in the spring of 1932. The company's policy was to design its offices to conform to the community, so the building featured an English Tudor motif that complemented Birmingham's civic structures. For decades, families brought burned-out lightbulbs to this building for free replacement. The building now houses a restaurant and bar.

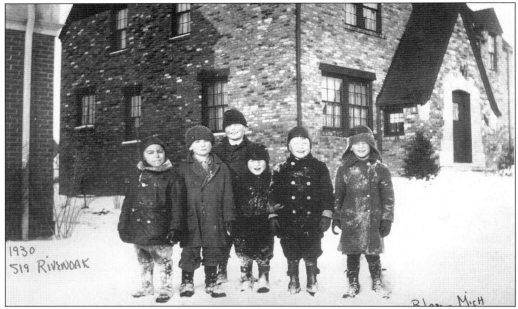

A group of frosty kids take a break from sledding in front of Harry Stone's house on Rivenoak Road in 1930. In those days, Poppleton Park's ball field was maintained by the neighborhood kids. The rest of the acreage was a meadow of uncut grass and trees. In the photograph above are, from left to right, Jack Steelman, Charles Stanley, Russ Fisher, Don Fisher, Bob Fisher, and Bud Stolberg.

Renowned architect Wallace Frost designed 44 stately houses in the city of Birmingham, dating from the 1920s through the 1950s. Frost met Detroit architect Albert Kahn while serving in the U.S. Army during World War I. Frost came to Michigan and worked on large Kahn projects such as the General Motors Building. Frost had an office on West Maple Road and designed his own house on Tooting Lane in 1921. The "Wally" pictured here is located at 551 Pilgrim Road.

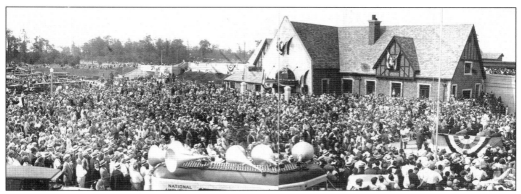

A giant all-day celebration was held on August 1, 1931, to mark the opening of the new train station and commuter service linking Birmingham with Pontiac and Detroit. It was the first commuter service in the state powered by steam and brought Birmingham closer to Detroit than ever before. It was made possible by purchasing land for new tracks east of Eton Road that bypassed the heart of the city.

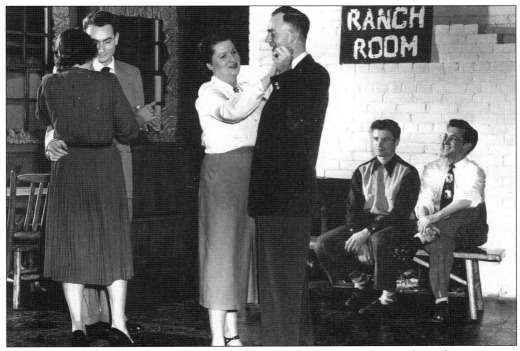

During the 1930s and 1940s, the Community House's "Ranch Room" was where the action was for area teenagers. Nearly 60 years later, Chick Holmes remembered sneaking into the Saturday night dances during the Depression when money was tight: "The 25 cents admission was a bit more than I could manage," the former Ford executive recalled, "but my buddies lent a hand by opening a basement window for me to crawl through."

Shoveling out has always been a necessary evil. Fortunately Birmingham rarely gets major snowstorms like it did even a generation ago. The clean sidewalk shown above is on Maple Road near Chester Street, looking east. In the distance on the left is the Wabeek Building, which dates this photograph after 1929. On the right is St. James Episcopal Church.

This 12-by-16-foot structure on Pierce Street probably qualifies as the smallest house in Birmingham. The tiny building was originally a plumber's office and later a laundry. In about 1936, Albert J. Bodine and his wife, Gertrude, moved in. Bodine once said the house was so small "you had to go outside just to change your mind." The house still stands but is no longer used as a primary residence.

Six

WAR AND PEACE

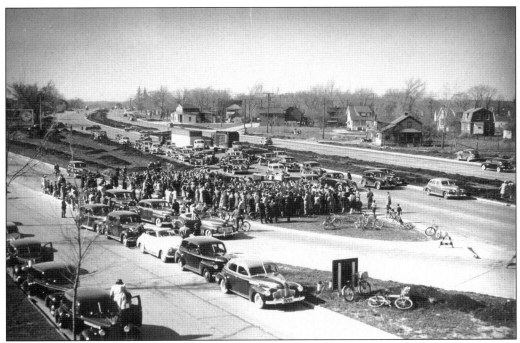

Everyone seems to be enjoying the celebration for the completion of the Birmingham Bypass in 1939. The road was known as Hunter Boulevard for several decades but was recently renamed simply Woodward Avenue. The stretch of Woodward Avenue that runs through town was renamed Old Woodward Avenue.

Hunter Boulevard (now Woodward Avenue) looks like a superhighway in this photograph taken in the spring of 1940. Poppleton Park can be seen on the right alongside cars whizzing toward Pontiac. After World War II, Quonset huts at Poppleton Park's fields were used briefly to house returning veterans.

When Hunter Boulevard (now Woodward Avenue) was built in 1939, a pedestrian tunnel was constructed under the roadway at Oakland Avenue for the safety of kids who had to cross Woodward Avenue to attend Adams School. Longtime residents remember the time a drunk tried to drive his Chevy down the steps late one night and got stuck. That would be a tough one to explain to the wife.

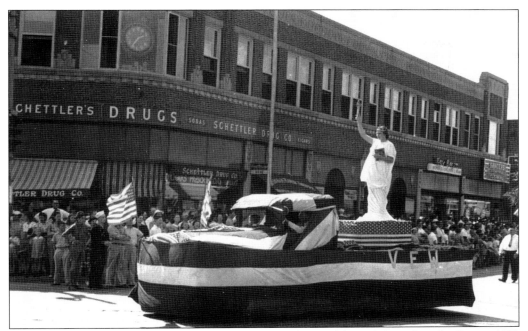

With the country inching slowly toward war, Birmingham celebrated Civic Loyalty Day in 1939 with a parade. Here the Veterans of Foreign Wars float is just turning off West Maple Road onto Woodward Avenue. Baldwin High School graduate Minnie Wade is atop the float in the role of Lady Liberty. Kay Baum's clothing store is located in the building behind her.

On Saturday, May 18, 1940, Birmingham celebrated the opening of its new post office on Martin Street. Two thousand spectators jammed the area for the dedication. World War I veterans, Girl Scouts, Brownies, and the Baldwin High School band all gathered to hear Gov. Luren D. Dickinson address the crowd. Postmaster Joseph A. Byrne said the post office was "built to last 100 years."

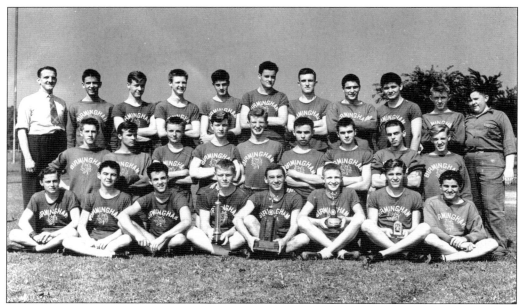

Baldwin High School won state championships in track and field in 1933, 1935, 1937, and 1942. The 1942 team was coached by Ernie Engel (back row, left). Sprinter Jack Steelman (front row, fourth from left) later ran track at Michigan State College and fought in Italy during World War II. Fred Zoellin (front row, fifth from left) was a pole-vaulter who lettered at Indiana University.

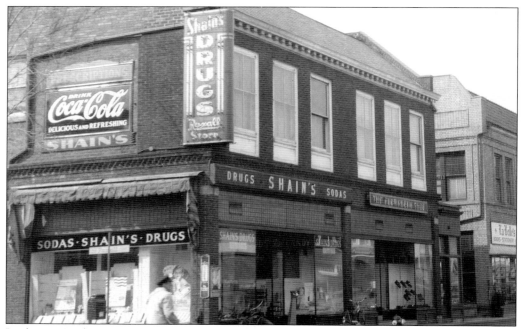

In the 1940s, drugstores were big hangouts. Shain's drugstore, shown here, was located at Maple Road and Pierce Street and had the best soda fountain in town. Wilson's was on the northwest corner of Woodward Avenue and Maple Road, and Cunningham's was on the southeast corner. Teens got their sliders at the White Tower, which was next to the Birmingham Theatre Building.

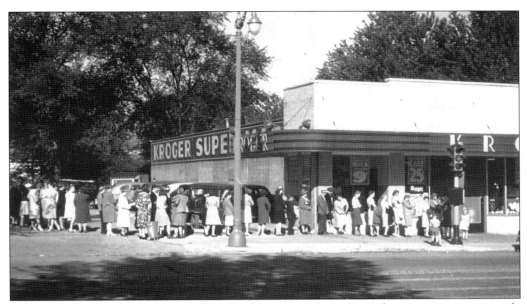

During World War II, food was rationed and lines were long. Here shoppers queue up outside the Kroger store on North Old Woodward Avenue at Willits Road. Limited food supplies were supplemented by "victory gardens" and home canning. Detroit became known as "the arsenal of democracy" during the war, and many men and women worked in area manufacturing plants to support the war effort.

Russell Fisher enrolled in the Navy ROTC while a student at the University of Michigan. The Baldwin High School graduate was commissioned as an ensign. He served as a communications specialist on the battleship USS *Idaho*, seeing action at Iwo Jima and Okinawa. Fisher grew up in Poppleton Park; his grandfather owned a farm at the southeast corner of Maple and Lahser Roads.

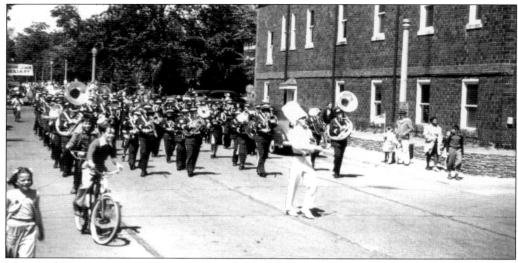

Memorial Day services and a parade were held on May 30, 1947, to honor servicemen who had died in World Word II. The parade started at Baldwin High School and ended at the municipal building. Mayor Ralph A. Main represented the city at a wreath-laying ceremony. The Baldwin High School Marching Band participated in the parade.The Baldwin High band is shown here marching past the Oddfellows Hall on Merrill Street in another late-1940s parade.

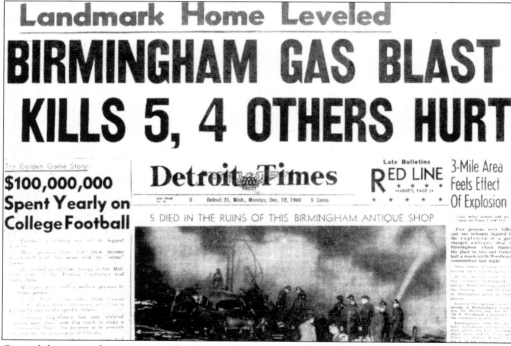

One of the worst disasters to strike Birmingham occurred on December 11, 1949. On that quiet evening, a huge gas explosion ripped through the Mother and Son Antiques shop at 720 North Old Woodward Avenue. Five people inside the shop were killed; only one person survived. Among the dead was the owner of the shop, Edith Jones. Houses on Brookside Avenue were also heavily damaged.

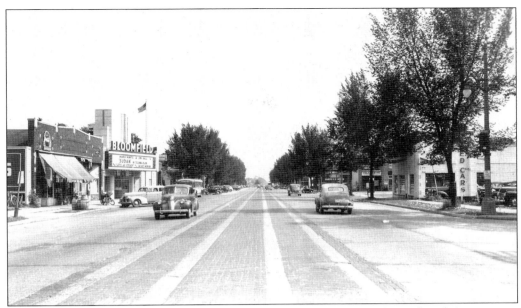

The Bloomfield Theatre was built in the late 1930s on the east side of Woodward Avenue, just south of Brown Street. Unlike the Birmingham Theatre, the Bloomfield Theatre was strictly a movie house and lacked the large, deep stage and dressing rooms for vaudeville performers or actors. The Bloomfield Theatre was also somewhat smaller, seating about 900 patrons, and was never as popular as its uptown rival.

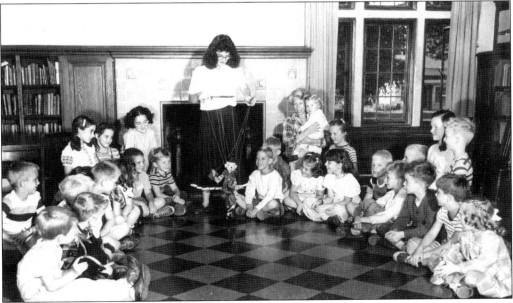

Baldwin Public Library has always been a gathering place for residents of all ages. After Martha Baldwin died in 1913, the village trustees unanimously approved the following resolution: "That the public library of Birmingham be named the 'Baldwin Memorial Library' in honor of Miss Martha Baldwin who has always been very active in its interests, and whose liberal gift made it possible to have an institution in our beautiful village."

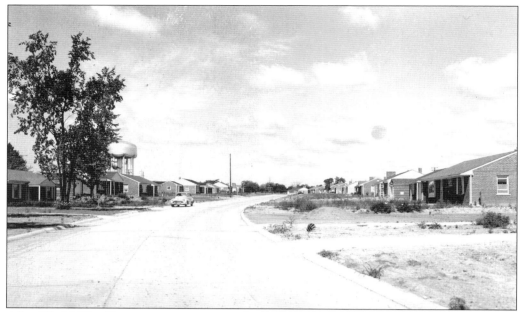

After World War II, servicemen returning from the war were ready to start careers and have families. By the 1950s, the baby boom was in high gear. Any street with lots of babies and toddlers was referred to as "diaper row." This shot shows Derby Road looking west toward Adams Road.

The best football player to ever wear a Birmingham High School uniform was unquestionably Tom "the Bomb" Tracy. He played halfback, fullback, and safety, and kicked for the Maples, graduating in 1952. Tracy played collegiately at Tennessee and enjoyed a nine-year career in the NFL with the Lions, Steelers, and Redskins.

The St. James Pet Parade and Children's Fair was an annual event that began in the 1920s. Maple Road was roped off in front of the church, and booths featured fortune-tellers, magic shows, needlework, games of chance, and ice cream. All pets were welcome, and the parade attracted some unusual entries, such as in 1943 when amateur beekeepers Johnny and Peter Hubert brought some of their bees.

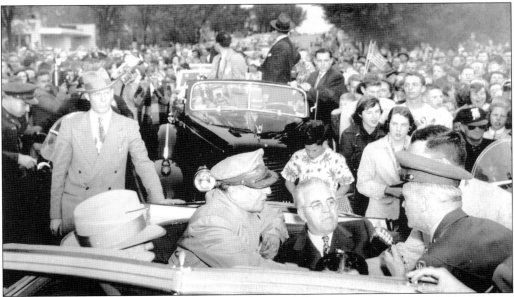

After he was relieved of his command in Korea in 1952, Gen. Douglas MacArthur toured the United States. His itinerary included a visit to Birmingham, where he gave a brief speech near the corner of Old Woodward Avenue and Harmon Street. As the last great general of World War II to come home, General MacArthur was given a hero's welcome. He thanked Birmingham's servicemen for their sacrifices and was quickly off to Pontiac.

Crowded classrooms in the Birmingham public schools were a concern during the baby boom years. In 1954, district voters approved a $3.5 million bond issue to fund an addition to the recently completed high school (now Seaholm) and build a new junior high school. Derby Junior High School was completed in 1958 at a cost of just under $2 million.

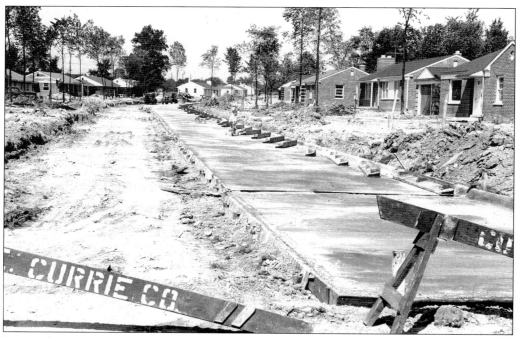

Birmingham's housing boom after World War II paralleled major growth in the automotive industry. Birmingham's population increased from approximately 11,200 people in 1940 to 15,000 in 1950, and to 25,000 in 1960. This undated photograph shows Pembroke Road, probably about the time that Pembroke Elementary School was built in 1955.

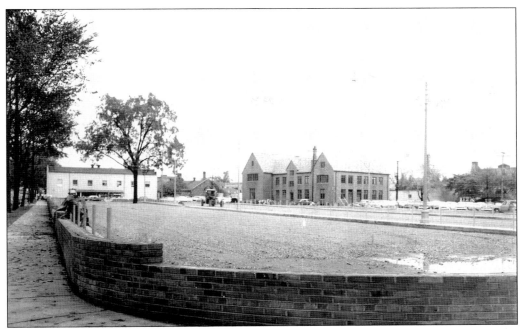

Before the Pierce Street Parking Structure was built, the Pierce Street Parking Lot occupied the site. Prior to that, a short street with a few houses on it called Gray Court extended east from Pierce Street. In the 1930s, the Oddfellows Hall was located in the building that the Varsity Shop is in today. A consignment shop called the Trading Post operated by Joyce Packard later occupied the building.

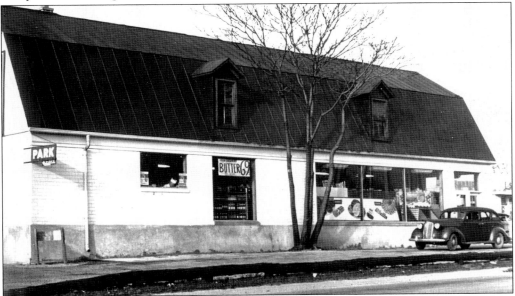

Peabody's Market opened in 1946 at 154 Woodward Avenue. The building was originally a mill. It was built in 1904 by William E. Smith, whose family sold it to Stanley Peabody in 1928. Jim Peabody converted the market to a restaurant in 1975. The original structure burned down on January 9, 1980, but was quickly rebuilt. The restaurant is now run by Jim's daughters.

David Bradbury proudly holds up the trophy for his winning fish in the Quarton Lake Carp Derby in this 1960 photograph. The monster was 23 inches long and weighed in at 5.5 pounds. Nobody will ever confuse Quarton Lake with Malibu, but it has provided lots of four-season fun for area residents, including speed skater Sheila Young, who won gold, silver, and bronze medals at the 1976 Winter Olympics.

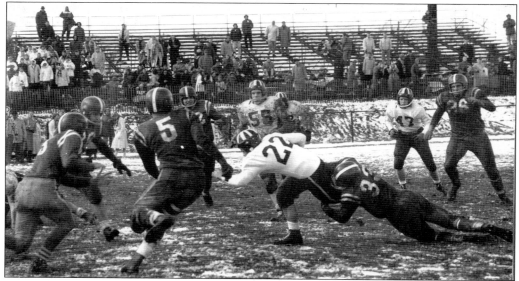

Birmingham High School's annual Thanksgiving Day football game against Royal Oak was a tradition that began in 1924. The winner took home the "Little Brown Jug." The photograph above is from the 1956 game, which was played at what is now Maple Field. Birmingham's home field was at Pierce School until the new Birmingham High School opened in 1952. Birmingham High School was renamed Seaholm when Groves opened in 1959.

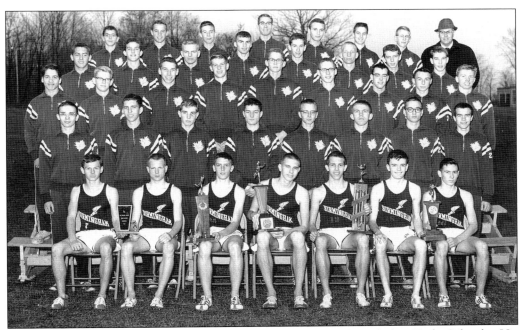

Kermit Ambrose was a beloved coach at Birmingham and Seaholm High Schools. His cross-country teams won state championships in 1959 and 1963. After retiring from coaching, Ambrose was the director of the Huron Relays for 21 years, officiated various sporting events, and ran several sports camps. The 1963 team is shown above. Ambrose is in the back row, far right. Now well into his 90s, Ambrose lives in Royal Oak.

Gov. George Romney (1907–1995) lived in nearby Bloomfield Hills but got his news from Birmingham's hometown newspaper. Romney was governor of Michigan from 1963 to 1969. During Birmingham's centennial celebration in April 1964, he gave an address in Shain Park and his wife, Lenore, participated in a symposium on "The Role of Women in Politics" at the Community House.

Jack Bachelor was a distance runner for Seaholm High School in the early 1960s. He was later an All American at Miami of Ohio and then joined the prestigious Florida Track Club. Bachelor came down with food poisoning at the 1968 Olympics in Mexico City and could not run. At the 1972 Olympics in Munich, he finished ninth in the marathon. Bachelor's friend Frank Shorter won the gold medal.

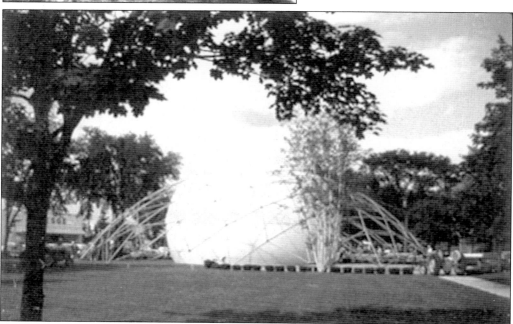

The Birmingham Jazz Festival was held in the early 1960s under a trendy geodesic dome erected in Shain Park. Performers included jazz greats such as Toots Thielemans and Junior Mance. The *Birmingham Eccentric* called it "Newport on a small scale." A CD of the 1960 concert was recently released. The dome is under construction in this photograph.

Paul (Noel) Stookey (second from left) of Peter, Paul, and Mary grew up at 288 West Lincoln Street and attended Birmingham High School. Other celebrities who attended Birmingham schools, grew up, or lived here include architect Eero Saarinen, actress Christine Lahti, Olympians Sheila Young and Jack Bachelor, comedian Tim Allen, soccer player Alexi Lalas, and of course, Park Street's Clare Cummings, known to generations of kids as Milky the Clown.

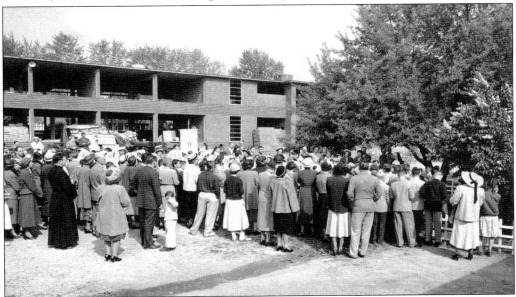

The baby boom also resulted in overcrowding at Holy Name School. In 1950, an addition to the 1928 school was completed. A second addition was completed in 1961 that included three classrooms, a library, and a boy's locker room.

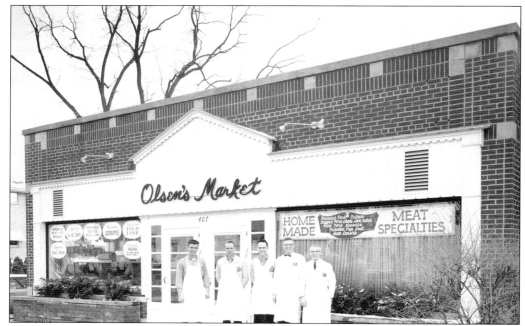

Merritt Olsen and the staff of Olsen's Market pose proudly for this Birmingham Centennial photograph that ran in the *Birmingham Eccentric* in 1964. The men are, from left to right, Richard Raymond, Robert Carney, Phil Jones, Merritt Olsen, and Harold Rood. Olsen often surprised customers at the meat counter by playing a tune on his fiddle or dulcimer. The market was located at Brown and Chester Streets and is now an art gallery.

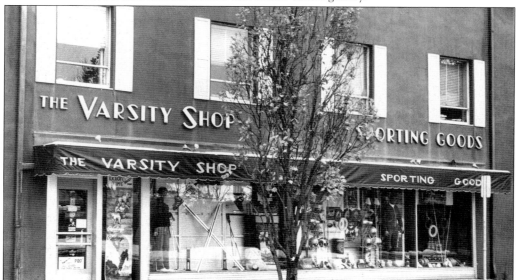

Many trendy retailers have come and gone since the Varsity Shop first opened its doors in 1954 at the corner of Merrill and Pierce Streets. The cozy sporting goods store was founded by former Birmingham High football coach Vince Secontine and is now run by son Marc. The store has a hometown feel that the larger chain stores cannot match, including a "Winners Wall" that spotlights local athletes and teams.

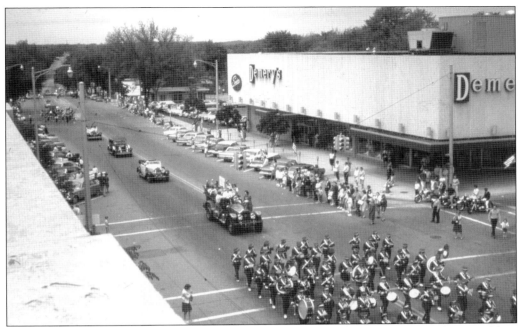

Birmingham celebrated its centennial in May 1964 with a week of events. The Edison Building presented a history display, the U.S. Marine Corps Band performed at Seaholm High School, a carp fishing contest was held at Quarton Lake, and a centennial king and queen were crowned in Shain Park. In this photograph, Merritt Olsen drives Birmingham's American LaFrance fire truck down Old Woodward Avenue toward Maple Road during the centennial parade.

City manager Dick Gare stands up to make a point at this city commission meeting in 1964 or early 1965. Seated are, from left to right, Charles Clippert, Carl Ingraham, Gare, Mayor Charles Renfrew, city clerk Irene Hanley, Dave Breck, William Burgum, and Bob Page.

The Seaholm High School boys' swim team won four Class A state championships, 1962–1965. The 1964 team is shown here. The Maples were coached by Cory Van Fleet and led by All-American Roddy Henderson. Henderson was an Olympic-caliber sprinter but died along with two other Seaholm High School students in 1965 when his car was struck head-on by a drunk driver on Maple Road near Lake Park. Henderson is in the front row, far right.

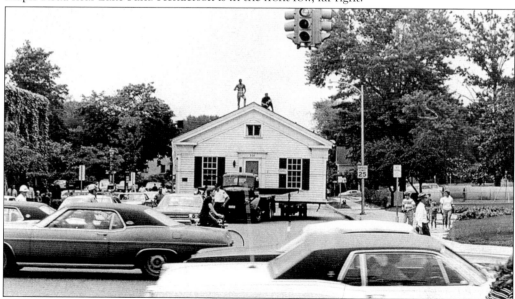

In 1964, James K. Flack bought the historic Hunter House, then located on Brown Street, and gave it to the City of Birmingham. On July 24, 1970, the Hunter House's chimney and west side addition were removed, and it was placed on skids and moved to its present location at the Birmingham Historical Museum and Park.

Jacobson's first opened its doors on Maple Road in 1950 and experienced phenomenal growth in the 1950s and 1960s. In 1954, Jacobson's opened a home decorative shop and beauty salon on North Old Woodward Avenue; in 1956, Jacobson's opened its children's store at Old Woodward Avenue and Willits Road; and in 1962, the men's store opened across the street.

Florence "Twink" Willett was Birmingham's first woman mayor in 1960. Concerned about the vitality of the downtown, she told the *Birmingham Eccentric* in 1969, "If people who live here don't support local independents we'll find ourselves with a town of chain stores and the character of the business community will change." She is shown here with Thomas D. Given in 1968.

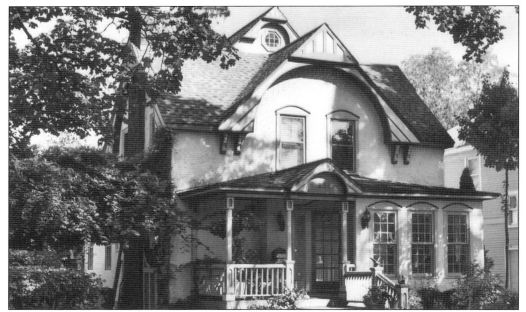

At the height of the civil rights movement in 1966, the Birmingham-Bloomfield Community on Open Housing began its push for fair housing. In 1967, the Birmingham City Commission passed an open-housing ordinance. Opponents conducted a successful petition drive that placed the issue on the 1968 ballot, but their effort failed. Birmingham voters approved the first open-housing ordinance in the country by a 4,205-3,822 margin.

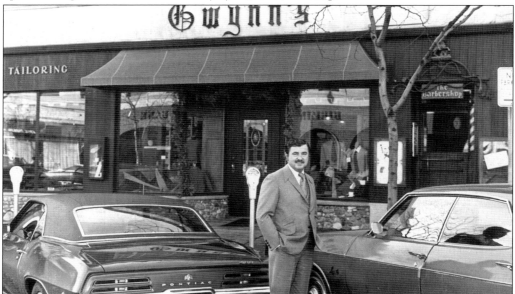

Bob Gwynn owned a successful men's clothing store for many years in the Johnston-Shaw Building at 112 South Old Woodward Avenue. Gwynn expanded the store in 1968, acquiring paneling and antiques in England to provide the right ambiance for local clotheshorses. The photograph above of the dashing Gwynn was taken in January 1970 for the *Birmingham Eccentric*'s special issue celebrating the town's sesquicentennial.

The Village Pub teen center was rechristened the Birmingham Palladium in 1970. It was promoted as a safe alternative to the Grande Ballroom and became a major concert venue for suburban teens. Bob Seger and SRC headlined on opening night. Other acts that appeared at the Birmingham Palladium included Ted Nugent and the Amboy Dukes, Alice Cooper, the MC5, and Iggy Pop. The Birmingham Palladium was located at 136 Brownell Street, now Peabody.

The Birmingham Hockey Association played its games for years on an outdoor rink at Eton Park, now called Kenning Park. The players shoveled the rink themselves between periods. This midget team from the early 1970s was coached by local painting contractor and noteworthy cigar chomper Jerry Fry (top left). In 1973, the $1.15 million Birmingham Ice Arena opened, signaling the arrival of the Zamboni age.

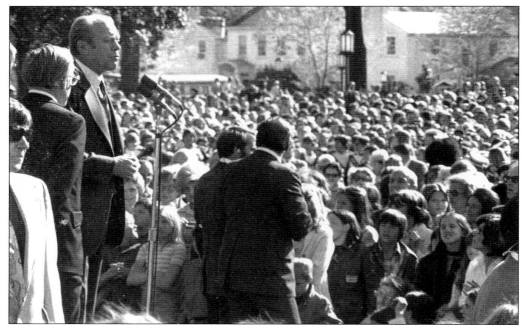

In 1976, Pres. Gerald Ford made a campaign stop in Shain Park. Former mayor Ruth McNamee coordinated events with President Ford's staff, assuring them that Birmingham would not come unglued by a presidential visit. "In some communities, they flip," she explained. The Secret Service was everywhere and even inspected the Seaholm Maples Chorale's piano. Ronald Reagan made a Shain Park appearance four years later.

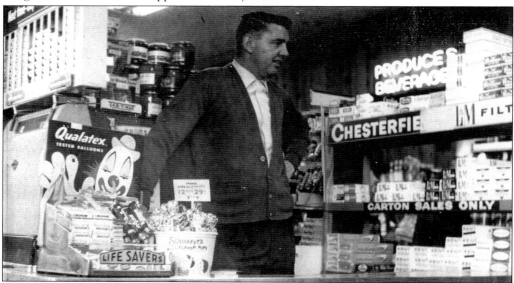

Jim Peabody was the grandson of a homesteader who purchased a square mile of land in Bloomfield Township in the 1880s. Peabody's parents, Stanley and Louise, opened Peabody's Market on Woodward Avenue in 1946. Peabody closed the doors on the barn-style building in 1975 and converted it to a restaurant. The likable and lanky Peabody graduated from Birmingham High School in 1937 and was an ardent supporter of the city.

Seven

OUR TOWN

More than a dozen works by leading 20th-century figurative sculptor Marshall Fredericks are located in public areas in Birmingham. These include the *Veteran's Memorial* at city hall, *American Eagle* at the First Presbyterian Church, *Two Bears* at Quarton School, and *Freedom of the Human Spirit*, shown above, at Shain Park. Fredericks lived on Lake Park. Birmingham is a grateful beneficiary of his creative genius.

In the 1970s, *Creem* magazine's offices were in the Birmingham Theatre Building. In the photograph above taken in August 1974, Gene Simmons, Paul Stanley, and Peter Criss of the band Kiss apply their makeup in the men's room that *Creem* shared with a local dentist, prior to a photo shoot. The rock-and-roll magazine eventually moved to Los Angeles and is no longer in business.

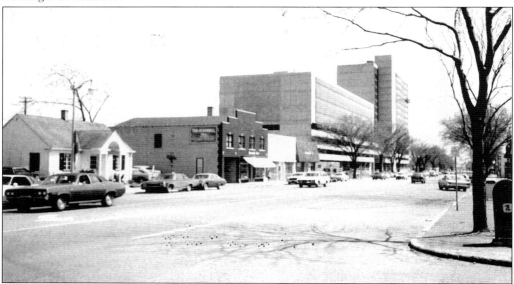

Construction of the 555 building was extremely controversial in the 1970s. Opponents argued that the 15-story building was not in keeping with the residential, small-town nature of the community. Proponents such as Mayor Dave Breck believed that the automobile businesses that dotted Woodward Avenue south of the downtown area provided a shabby gateway to the city and supported the construction of the austere high-rise as the best alternative.

The Birmingham Theatre began showing theatrical productions again in 1978. "As now as New York, as near as Woodward and Maple!" a promotional brochure boasted. Productions the first season included *Les Girls Les Girls* starring Cyd Charisse, *P. S. Your Cat is Dead* starring Roddy McDowell, and the John Houseman Acting Company. The Birmingham Theatre was tastefully converted to a multiplex motion picture theater in 1996.

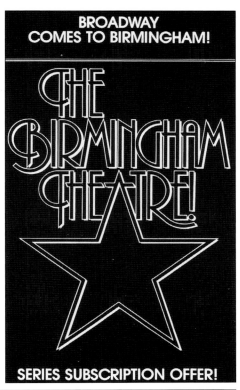

The Concerts in the Park music series began in 1977. Funded by the city and private contributions, concerts include all types of music. The director of the Concerts in the Park series is former longtime Parks and Recreation Board member June McGregor, who books the bands and manages the events. In recent years, concerts have included an African World Festival, Polish Festival, and Scots Festival.

119

Baldwin House senior citizen housing was completed in 1993 on the site of Old Hill School at Chester and Martin Streets. The building has 144 apartments, 13 of which are barrier free. Baldwin House was developed in cooperation with the Michigan State Housing Development Authority. Whether senior housing should come to Birmingham at all was a major controversy in the 1970s.

are standing around the perimeters of her classroom in a circle, moving back and forth and using lots of hand movements as they recite multiplication tables.

"1 times 6 equals 6," they recite enthusiastically, in unison.

"2 times 6 equals 12," they continue, reciting

tary school that uses Waldorf methods in metro Detroit, where there are four private Waldorf schools.

Though the Waldorf method is religion-based, Oasis and other public schools that use it have adopted its non-spiritual aspects, while leaving out things such as morning and after-

make their case.

The school's 5-year-old charter, which has been authorized by Central Michigan University, expires Aug. 8, and the Oasis board of directors refuses to sign a new contract with CMU,

Please see WALDORF, Page 6B

Bigfoot builders race clock

More time was granted after rush for permits

BIRMINGHAM

By BRIAN BALLOU
FREE PRESS STAFF WRITER

New construction on so-called bigfoot homes in Birmingham is expected to hit a fervent pace in the next several weeks despite an ordinance last May banning such developments.

Developers flooded the planning department during May with permit requests to build homes that weren't subject to the upcoming size restrictions. Fifty-eight permits were received and approved.

The city has received about 10 applications for home developments since the ordinance went into effect. The ordinance limits the height of new homes to 30 feet and the area of homes to 35 percent of the lot.

"We've got quite a boom with new businesses downtown, but

we're expecting to see an even larger home-construction boom in the next couple of weeks," building official Mary Ferrario said.

The deadline for breaking ground on homes approved before the ordinance went into effect was Nov. 25, but because of the number of permits, Ferrario said she extended the deadline to March 31.

Developers holding permits for bigfoot homes must start con-

Please see BIGFOOT, Page 6B

PATRICIA BECK/Detroit Free Press

A bigfoot is under construction on Pierce in Birmingham on Thursday. Developers holding permits for bigfoots must start construction by March 31. A city ordinance bans them after that.

In 2000, the city commission passed an ordinance that limited the size and height of houses. The ordinance responded to widespread complaints by citizens about "bigfoot" houses that loom alongside smaller houses. Building ordinances were adjusted in 2006 to encourage designs that are more aesthetically appealing. "The pendulum on development in Birmingham is always swinging back and forth," said former mayor Don Carney.

Seaholm's girls' athletic teams have been extremely successful in recent years. The Seaholm/Groves Unified lacrosse team won state championships in 1998, 1999, and 2001 (shown above) under coach Mary-Ann Meltzer, who is now the head coach at the University of Michigan. The 2007 team also won a state championship. The Seaholm High School girls have also won recent state championships in soccer, swimming (a three-peat), golf, and tennis.

The Townsend Hotel opened in 1988 and expanded in 2000 on the site of the Hughes, Hatcher and Sufferin store. The Rolling Stones, Madonna, Rod Stewart, and the Los Angeles Lakers have all slept in the Townsend's 150 swanky suites. Shortly after the Townsend opened, Paul McCartney's kids made headlines for throwing water balloons at people on the street who were wearing fur—good thing the Potawatomis had already left town.

The Birmingham Bloomfield Community Coalition was established in 1995 to prevent the abuse of alcohol, tobacco, and other drugs. The organization works with schools, law enforcement, and community groups to build awareness and support prevention efforts. Each summer the organization sponsors a Battle of the Bands in Shain Park that provides a stage for talented high school kids to rock on—safely.

The $63 million, 262,000-square-foot Willits building was completed in 2002. The Willits has two restaurants on the first floor and 58 condominiums on the next four floors. Residents of the elegant Willits are part of a recent trend toward downtown living in Birmingham and other communities around the country.

The $2.5 million Quarton Lake Restoration Project was completed in 2004. The lake was dredged, the shoreline was stabilized to minimize erosion, and massive boulders were installed to keep wild geese and ducks away from the water. As a result, the lake is more accessible to both people and wildlife. The award-winning project was funded with grant money and part of a $25 million park bond approved by residents in 2001.

The Birmingham Jazzfest has become an annual summertime event. Concerts are held in Shain Park and at other venues around town. Sponsored by the Community House, the first Jazzfest was held in 1992. In this photograph, internationally known pianist and Broadway composer Bob James plays for a mellow Shain Park crowd in 2005.

The Woodward Dream Cruise started in 1995 as a one-time event to raise funds for a children's soccer field. It has become an international family-friendly celebration of the classic car culture of the 1950s and the 1960s. Woodward Avenue from Ferndale to Pontiac is crammed with 1.7 million people who want to check out the hot tailfins and reminisce about cruising in the days of Maverick's drive-in and four-barrel Holley carbs.

One reason that Birmingham continues to be a desirable community is because it has a walkable downtown—a rarity in an era of mega malls, strip malls, chain stores, and urban sprawl. In recent years, more and more restaurants and cafes have set up tables for outdoor dining.

Eight

THE BIRMINGHAM HISTORICAL MUSEUM AND PARK

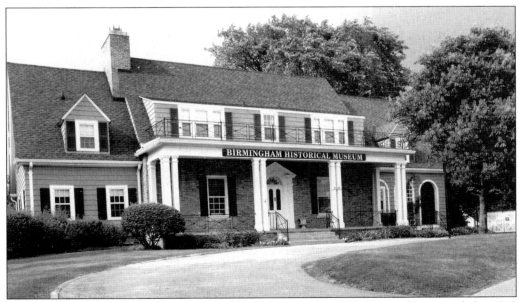

The Birmingham Historical Museum and Park features the 1822 Hunter House and the 1928 Allen House. These historic buildings sit side by side at 556 West Maple Road. The mission of the museum is to preserve, protect, and promote the community's unique heritage. A primary focus of the museum is to expand educational programs for area schools.

Harry and Marion Allen wanted their home and property to be preserved for future generations. The Birmingham Historical Museum and Park opened on May 19, 2001, and offers three changing exhibit galleries, a gift shop with local history books and souvenir items, and a historical records library. Genealogists and researchers are welcome to schedule research visits.

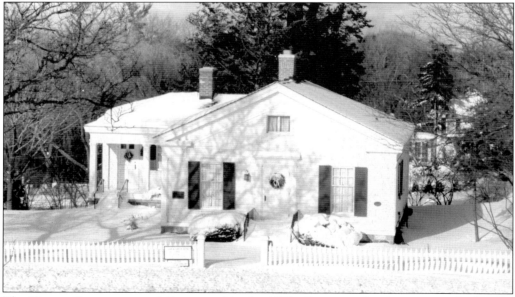

The Hunter House was carefully restored in the 1970s. For most of its history, people thought the Hunter House was a Greek Revival. When it was built, the Hunter House featured a simple design featuring plank construction incorporating top and bottom sills. The planks were probably sawed at a mill that opened in Pontiac in about 1820. They were delivered to Birmingham by wagon on the Saginaw Trail.

The Hunter House features furniture and accessories from the 1830s through the 1880s. Since John West Hunter owned a foundry, it is believed that a stove—not a fireplace—was the source of heat for comfort and cooking. A set of sleigh bells is the only artifact belonging to original owner Hunter. Sleigh bells were used in those days to warn others on the trail and scare off wild animals.

The Birmingham Historical Museum presents a model train display each year during the holidays. The museum is also a popular stop during Birmingham's annual First Night New Year's Eve Celebration.

ACROSS AMERICA, PEOPLE ARE DISCOVERING SOMETHING WONDERFUL. *THEIR HERITAGE.*

Arcadia Publishing is the leading local history publisher in the United States. With more than 3,000 titles in print and hundreds of new titles released every year, Arcadia has extensive specialized experience chronicling the history of communities and celebrating America's hidden stories, bringing to life the people, places, and events from the past. To discover the history of other communities across the nation, please visit:

www.arcadiapublishing.com

Customized search tools allow you to find regional history books about the town where you grew up, the cities where your friends and family live, the town where your parents met, or even that retirement spot you've been dreaming about.